For my sister, Alexa,
who can mangle a quote
better than anyone
I know.

To Alix Ele
A writer of
from
Your staunchist
admirer!
Thanksgiving
2011
My love
A.G.

Artful Words

Artful Words

mary engelbreit and the illustrated quote

text by patrick regan

**Andrews McMeel
Publishing, LLC**

Kansas City

06 07 08 09 10 MND 10 9 8 7 6 5 4 3 2 1

ISBN-13: 978-0-7407-6001-3
ISBN-10: 0-7407-6001-7

Library of Congress Cataloging-in-Publication Data

Engelbreit, Mary.
 Artful words : Mary Engelbreit and the illustrated quote/text by Patrick Regan.
 p. cm.
 ISBN-13: 978-0-7407-6001-3
 ISBN-10: 0-7407-6001-7
 1. Engelbreit, Mary--Themes, motives. I. Regan, Patrick, 1966- II. Title.

NC975.5.E54A4 2006
741.6092--dc22

 2006042902

www.andrewsmcmeel.com

ATTENTION: SCHOOLS AND BUSINESSES
Andrews McMeel books are available at quantity discounts
with bulk purchase for educational, business, or sales promotional use.
For information, please write to: Special Sales Department,
Andrews McMeel Publishing, LLC, 4520 Main Street, Kansas City, Missouri 64111.

contents

illustrations

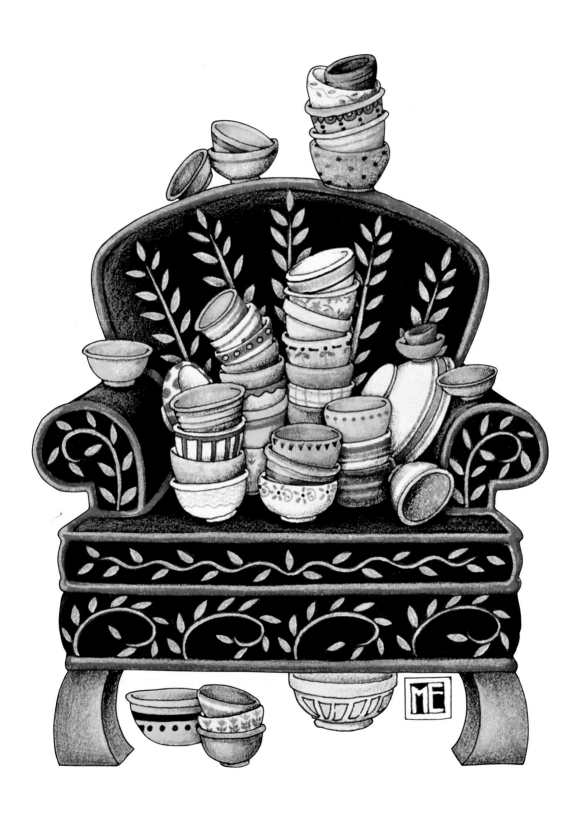

introduction

What came first, the bowl of cherries or the chair of bowlies? After nearly thirty years of Mary Engelbreit artwork, it's sometimes hard to remember. Over the past three decades, Mary has created a remarkable collection of images that have settled comfortably into our culture. She has made icons of teapots and cottage roses. She has made heroines of straw-hatted little girls and given rise to a generation of self-crowned queens. Even the most commonplace items, like watering cans, mixing bowls, and of course, cherries, have gained star status thanks to Mary's prolific pens.

Mary Engelbreit has accomplished a rare feat for a contemporary artist. She has developed a trademark style that is instantly recognizable to fans around the world.

But how did Mary's signature style get to be so? What is it that makes her work strike a chord with so many? Like her art, the answer to this question is multidimensional and more complex than it might first seem. But one thing that surely sets Mary's art apart is the substance behind the style. And as she is quick to point out, that substance, to a large degree, has always come from words. For Mary, words and pictures—like the lyrics and melody of a great song—have always gone together.

In this book, Mary takes a long look back at her art and its inspirations, paying particular attention to the words that have inspired the indelible images she has created. She discusses how she first came to associate images and words and how half-century-old children's books influenced her distinctive style. She talks candidly about her lifelong love of reading and her compulsive collecting of quotations. She tells the stories behind some of her most popular pieces and addresses the question she is asked perhaps more often than any other: "Where do you get your ideas?"

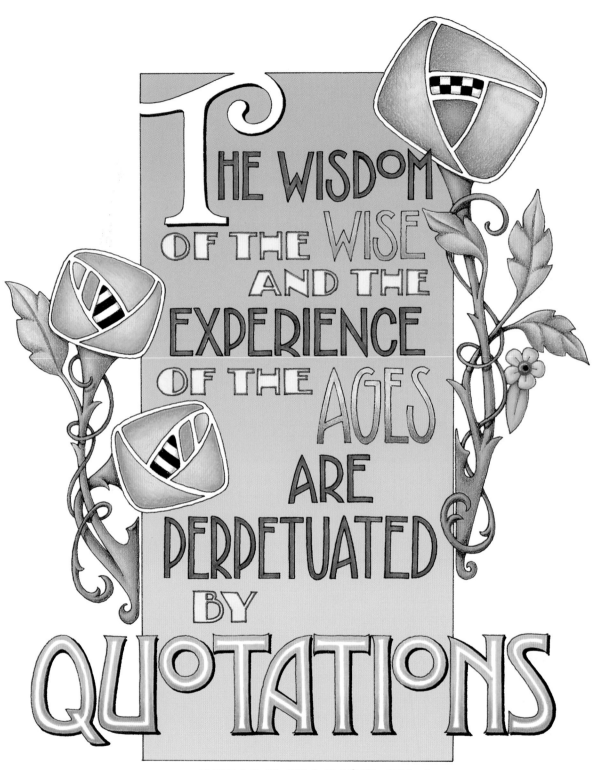

THE WISDOM OF THE WISE AND THE EXPERIENCE OF THE AGES ARE PERPETUATED BY QUOTATIONS

BENJAMIN DISRAELI

beginnings

Welcome to the happiest accident imaginable.

Nearly thirty years ago, Mary Engelbreit packed off to New York City from her home in St. Louis single-minded in purpose. Since childhood, she had wanted to be a children's book illustrator. With a trip to visit several publishing houses in New York, she was determined to make it happen. A lifetime (albeit a short one) of reading, drawing, and developing an artistic style had prepared her for her chosen vocation. It all seemed pretty straightforward.

But the New York publishers weren't buying. In a story familiar to her fans, Mary was turned away repeatedly with the somewhat deflating admonition to try her luck with greeting cards.

Even casual fans know the rest of the story. Mary did try her luck with greeting cards, and she met with success from the start. After selling her designs to various card companies for a few years, Mary formed her own company and in the early 1980s went back to New York City, this time to the National Stationery Show. She showed a meager twelve cards that first year, but the response was overwhelming. The orders poured in. The plucky girl from St. Louis was a genuine sensation. Within two years, her little company was selling a million cards a year. Calendars, stationery, gifts, and an amazing array of licensed products would follow.

Today, her success in the card business seems almost predestined, but in truth, it was anything but. Mary knew nothing about the card business. She didn't know about target markets or sending occasions or consumer behavior. What she knew was herself. She knew what she liked. And drew what she liked. And what she drew struck a chord with millions.

In those early days and for a good time afterward, Mary didn't stop to analyze what had made her such a success. There wasn't time, and it wouldn't

have suited her humble nature. But over the years, she developed a strong sense that it wasn't just the designs that set her cards apart. Then as now, there were better pure artists at work in the field, better technicians with pen and brush.

What distinguished her work, she now realizes, was not so much the art but its heart. From the beginning, Mary's work was different.

"These were personal drawings," Mary says of those early pieces that first garnered her such attention. "There wasn't anything like it out there at the time. People could tell they were different. They could tell there was a personal motivation behind the drawings. And from the beginning, there has always been a very personal response."

Mary's art spoke to card buyers from a place they understood. Here was a woman like them, a young mother trying to balance raising a family with making a living. An artist, yes, but also a friend, a wife, and a daughter. One of her very first cards serves as a perfect example. A very pregnant woman stands with her hands on the small of her back and a no-nonsense look on her face. The caption reads simply, "This Woman Deserves a Party."

For Mary, inspiration had come easily. She was, after all, eight and a half months pregnant when she officially launched her greeting card company.

From the beginning, Mary Engelbreit showed an uncanny ability to speak not only directly to the (primarily) women who bought her cards, but for them. "A lot of people I meet at signings say, 'I feel like I know you,'" says Mary. "Many of them say that they buy two of the same card, one to send and one to keep for themselves, because it means just as much to them as the person they're sending it to. That's really gratifying to me because it becomes a much more intimate thing. I feel like I'm personally communicating with these people."

From her earliest work, it was evident that Mary's cards were different, but the difference wasn't just in their artistic style. The difference was the message. As her husband, Phil, has pointed out, "Mary is more than an illustrator. She's a communicator."

Books are the quietest and most constant of friends; they are the most accessible and wisest of counselors, and the most patient of teachers.

Charles W. Eliot

Mary's cards, as it turned out, were a perfect reflection of her unique creative path. It's a path she was on long before she even realized it. At the time of this writing, it has been twenty years since Mary launched her first licensed card line with Sunrise Greetings, and thirty years or so since she sold her very first self-published cards. But the genesis of the Mary Engelbreit style goes back much further. To get to the real birth of Mary's signature style, you need to go all the way back to the bedtime stories her mother would read to Mary when she was just a girl.

Mary's mother loved the richly illustrated storybooks that her own mother had read to her as a child, and she had preserved a large collection of her favorites. These books, relics of the 1920s and '30s, captivated young Mary as well. To hear the artist speak of them now is to imagine her falling into their lavish illustrations and gleefully touring the fairy-tale castles and gingerbread houses. For Mary, these books gave her a glimpse of a perfect, fantastical world. She was hooked.

Looking back on those times some forty years later, Mary's mother would remember, "Mary loved to look at those old books. She could envision those fairy tales coming to life. Her all-time dream was to illustrate children's books. That's what she talked about all the time."

Without Mary realizing it, those books were instilling something in her that would prove to be profoundly influential in later years. The way these books were typically laid out, a line of text was often lifted out of the story and run above or below an illustration. While Mary may not have consciously taken notice of this interplay of words and image, many years later her greeting card designs would clearly reflect what she had seen and loved as a little girl. Words and pictures: They had always gone together.

"I really liked the way that looked," says Mary. "I liked incorporating type into the drawings and I liked lettering type. Nobody was doing that on cards back then, so it really made an impression."

Though she never really left them behind, Mary did move beyond those vintage storybooks. Once able to read on her own, she devoured what she calls the "classic girl books," such as *The Secret Garden, Jane Eyre, The Little Princess*, and the Nancy Drew series. As a teenager, she broadened her range. "My parents had one of those Great Books sets, and I read all of those," she remembers. "Dostoyevsky, Jane Austen, Dickens, George Eliot . . . and my father read a lot of mysteries, so I started reading those. Basically, I'd read whatever was around the house."

The only thing she loved as much as reading was drawing. For Mary, the two went hand in hand. "I would draw pictures to go with the stories I read," she explains. That's really why I started drawing."

In addition to creating her own illustrations to accompany the books she read, Mary picked up another lifelong habit in childhood. She began collecting quotes. "I always had a little notebook of quotes, even when I was little," she remembers. "When I read something I liked, I would copy it down." She has filled notebook upon notebook with quotes over the years. Many of these—some playful, some profound—have inspired illustrations.

To quote copiously and well requires taste, judgment and erudition, a feeling for the beautiful, an appreciation of the noble, and a sense of the profound.

Christian Nevell Bovee

It's often said that certain writers have "an ear for dialogue." Mary Engelbreit has something akin to the same ability. She has a knack for identifying quotes that ring true with others. Whether they come from literature, from published quote collections, or have been uttered by friends or family (the gems "Life Is Just a Chair of Bowlies" and "A Little Peace of Quiet" fall into this category), Mary seems to know instinctively which words will resonate with her audience and translate into a winning greeting card.

The acid test is simple. If Mary likes a quote, she goes with it. It's a naively straightforward system that would no doubt drive committees and experts crazy, but, with very little exception, it works. It works because Mary is her own consumer. "They're just like me," she says of the people who buy her cards. "What's important to them is important to me. What's funny to them is funny to me. And, of course, we've grown older together." The fact is that Mary is working for herself in every sense of the word, and always has.

From her earliest memories, Mary Engelbreit dreamed of illustrating children's books. But a funny thing happened along the way: She became the world's best-known greeting card artist and a giant in the gift, stationery, and home decor businesses (The Queen of Everything, you might say). But she did, ultimately, realize her childhood dream. She illustrated her first children's book

in 1993, Hans Christian Andersen's *The Snow Queen*. Other classic titles have followed, including Clement C. Moore's *The Night Before Christmas* and, most recently, a collection of the artist's favorite Mother Goose nursery rhymes. In fact, Mary now spends as much time on her growing line of children's books as she does on drawing new greeting card designs.

But in the past few years, Mary has accomplished something even she didn't expect. She's seen the publication of four children's books featuring Ann Estelle, that she not only illustrated but also wrote. People who know her well weren't surprised that she had it in her. "Look, she has had a lifelong love affair with books," her husband explains. "There are times where she'll complete three or four novels in a week. She knows good writing and really appreciates it. Writing these stories is another way for her to express herself . . . and make certain that her art is a good match for the words."

Words and pictures have always been a natural fit for Mary Engelbreit. She has tremendous reverence for words well written, whether poignant quotations or pithy one-liners, originally penned or the work of others. Mary realizes the power of just the right words at just the right time. And she well knows that words have had much to do with her tremendous success. From countless childhood hours spent on her mother's lap poring over antique storybooks to today's prolific output of best-selling books, cards, and calendars, Mary's love of the written word has served her well. And the happy accident of her career has brightened the lives of us all.

Mary selected the 110 illustrations that follow because they include some of her favorite quotations. Each was originally published on a greeting card that carried a second quote, from the artist, on its back cover:

This illustration is by Mary Engelbreit, who thanks you from the bottom of her heart for buying this card.

She has always had a way with words.

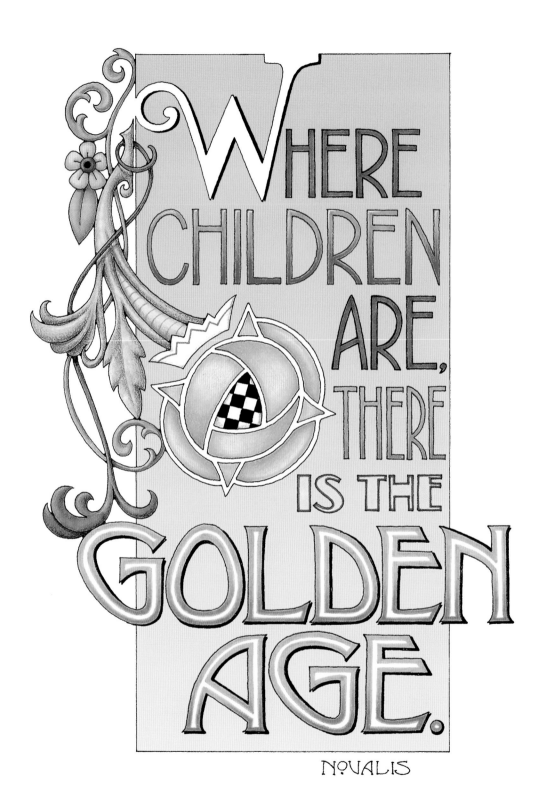

WHERE CHILDREN ARE, THERE IS THE GOLDEN AGE.

NOVALIS

children

Summer sand castles, autumn leaf piles, wild winter sled rides, and games of tag on spring-green lawns . . . kids at play provide inspiration for all seasons. For Mary, that inspiration comes not only from memories of her own childhood, but also from watching her two sons (and now her granddaughter) enjoy theirs.

Seen across the distance of time, the palette of childhood gains a richness. In our memories, the colors are saturated, the senses heightened. With a little prompting, we can conjure the sound of tree-house giggles or the feel of sand (or mud) between our toes. Childhood as witnessed and illustrated by Mary Engelbreit is equal parts discovery, wonder, silliness, tenderness, and unbridled fun.

Often, the quintessential moments of childhood are best captured with just an image. Mary has depicted many such vignettes so well that they seem clipped from our own family photo albums: a tea party with doll and teddy bear guests; a firefly hunt on a summer evening; a long, unsure hug on the first day of kindergarten.

But she also has a keen appreciation for those who can capture the magic of childhood in words. Mary illustrated one of her all-time favorite writings on the subject as a gift for her goddaughter. The piece, which poses and then answers the question, "Know you what it is to be a child?" is much longer than most quotes she has illustrated, but the power of its sentiment and imagery was too much for her to resist. "It just perfectly captures the wonder of it all," says Mary. "It was very easy to illustrate."

20

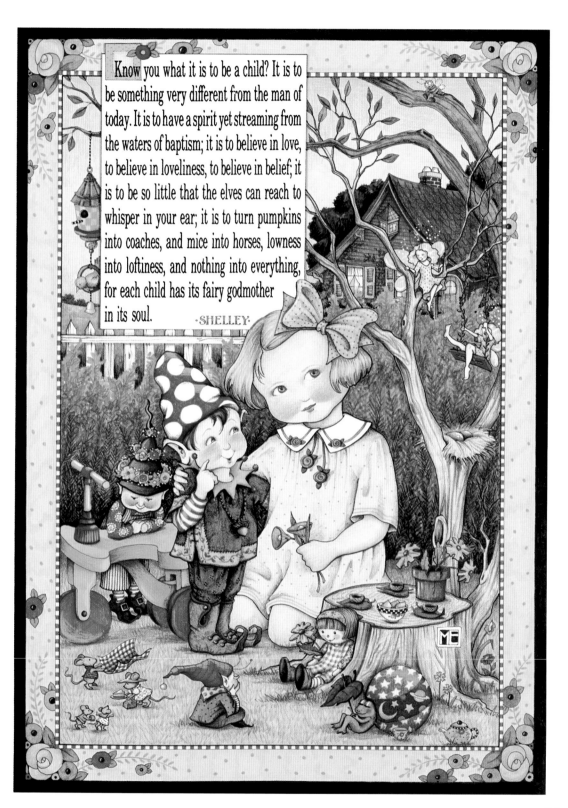

Know you what it is to be a child? It is to be something very different from the man of today. It is to have a spirit yet streaming from the waters of baptism; it is to believe in love, to believe in loveliness, to believe in belief; it is to be so little that the elves can reach to whisper in your ear; it is to turn pumpkins into coaches, and mice into horses, lowness into loftiness, and nothing into everything, for each child has its fairy godmother in its soul.

·SHELLEY·

from me to you

This is just a beautiful quote and it's how I felt about my babies—
that they were tiny, perfect little miracles.
There's nothing else that's such a great responsibility
and a great joy at the same time.

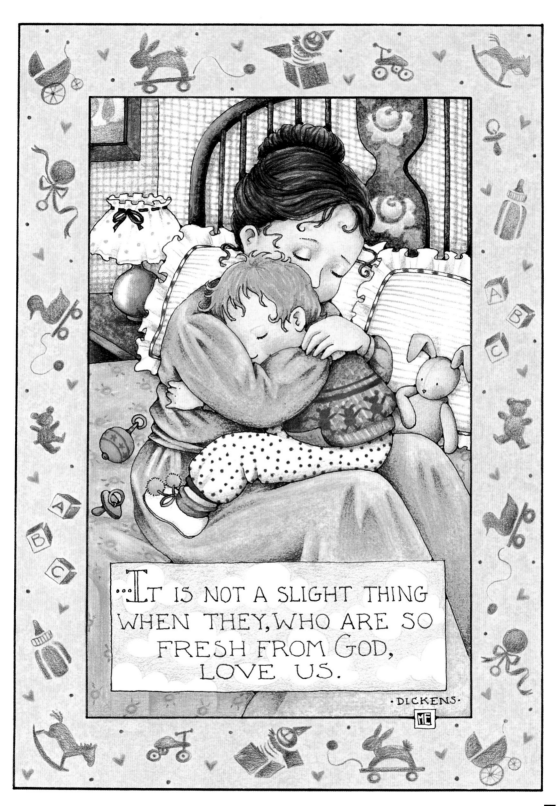

....It is not a slight thing when they, who are so fresh from God, love us.

·DICKENS·

ME

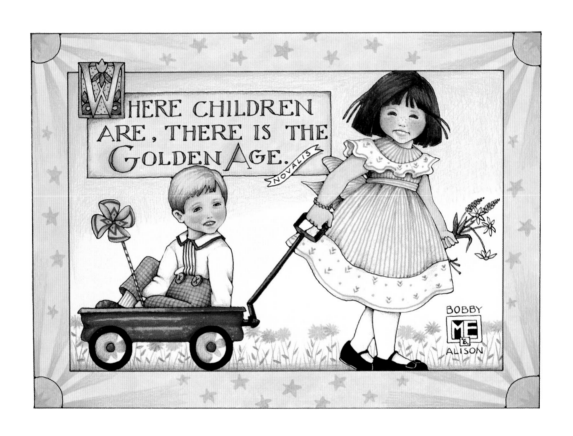

WHERE CHILDREN ARE, THERE IS THE GOLDEN AGE.

NOVALIS

BOBBY & ALISON

24

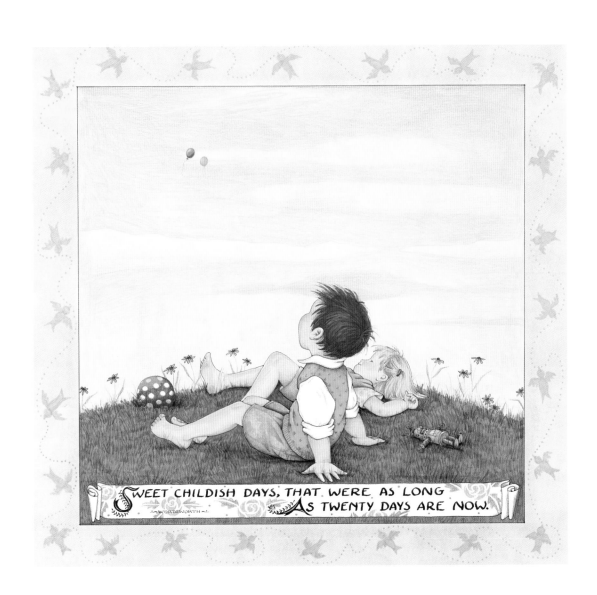

SWEET CHILDISH DAYS, THAT WERE AS LONG
~WORDSWORTH~ AS TWENTY DAYS ARE NOW.

from me to you

I did this for my son, Evan. I think this is a great quote,
although the story of Pinocchio is not one of my favorites.
I've always tried to draw "boy cards"
that my sons wouldn't be embarrassed to receive, but it's difficult.

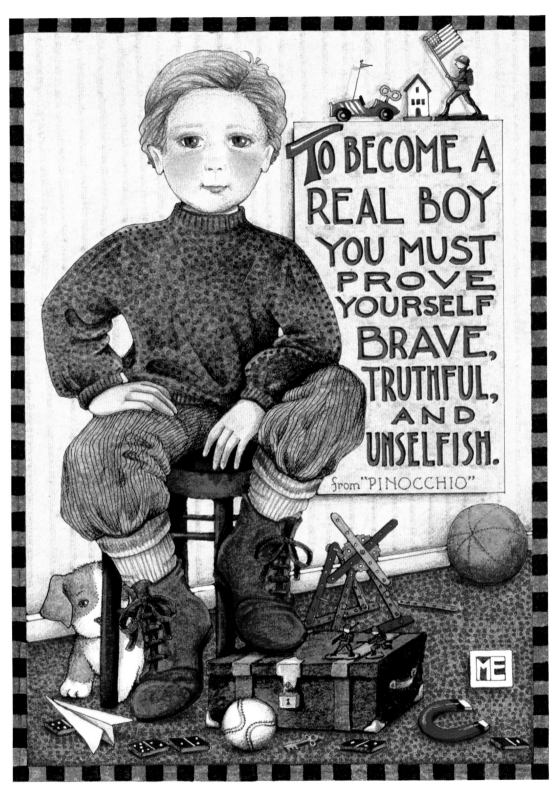

To become a real boy you must prove yourself brave, truthful, and unselfish.

from "PINOCCHIO"

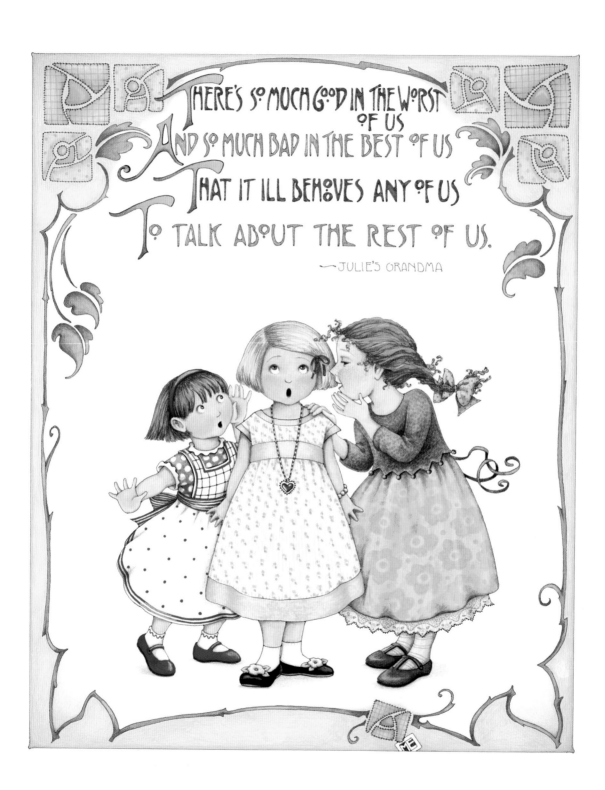

THERE'S SO MUCH GOOD IN THE WORST OF US
AND SO MUCH BAD IN THE BEST OF US
THAT IT ILL BEHOVES ANY OF US
TO TALK ABOUT THE REST OF US.

—JULIE'S GRANDMA

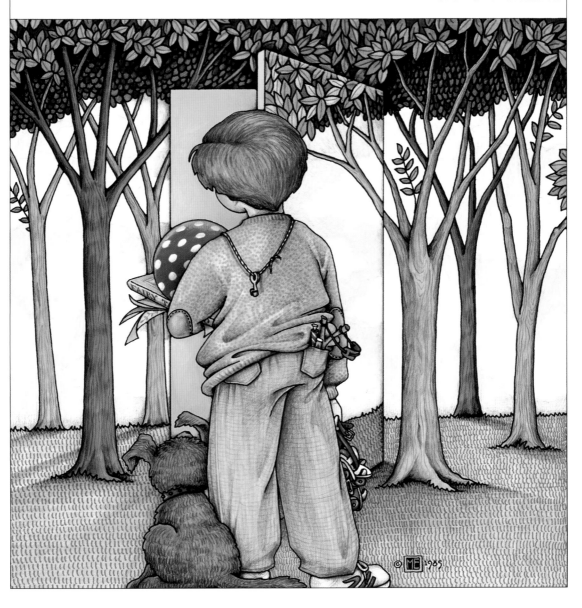

THERE IS ALWAYS ONE MOMENT
IN CHILDHOOD WHEN THE DOOR
OPENS AND LETS THE FUTURE IN.

— GRAHAM GREENE

from me to you

A lot of people don't notice this,
 but do you see the school bus off in the distance?
I did this in honor of skipping school.
I was a professional school skipper myself in high school.
 I always skipped for what I thought was a good reason
 and I usually had an accomplice—or several.
Amazingly, we never got caught. No one ever seemed to notice.
I really like this drawing because I think it captures
 the joy and freedom of that feeling.
That picture always hung in my boys' room.

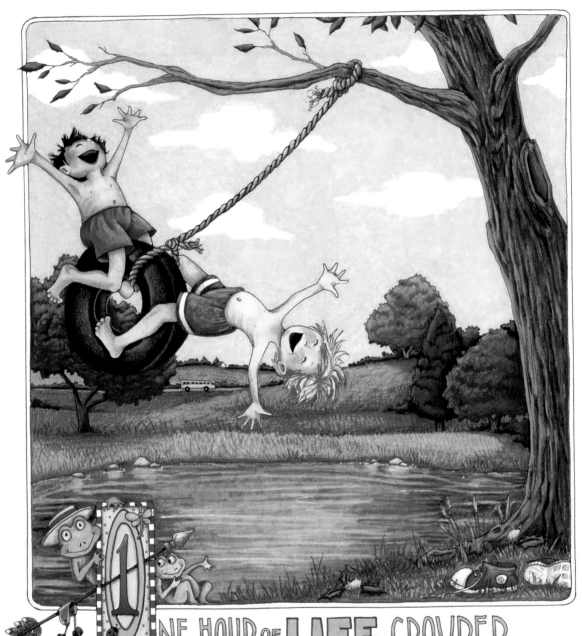

ONE HOUR OF **LIFE**, CROWDED TO THE FULL WITH *GLORIOUS ACTION* AND FILLED WITH **NOBLE RISKS**, IS WORTH **WHOLE YEARS** OF THOSE MEAN OBSERVANCES OF PALTRY DECORUM.

SIR WALTER SCOTT

31

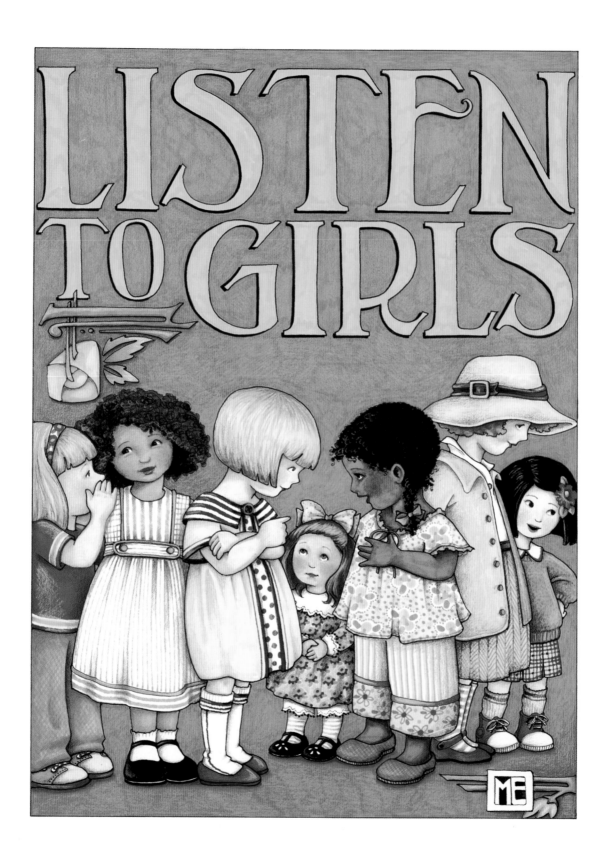

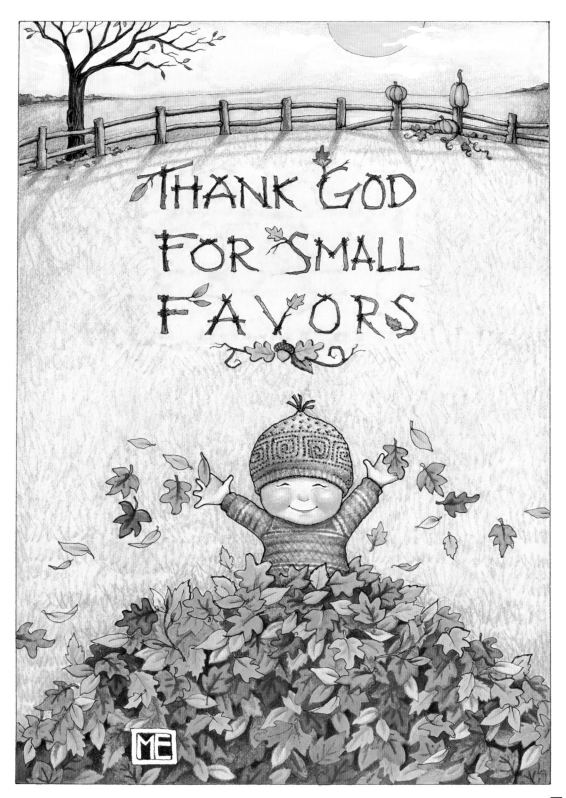

THANK GOD
FOR SMALL
FAVORS

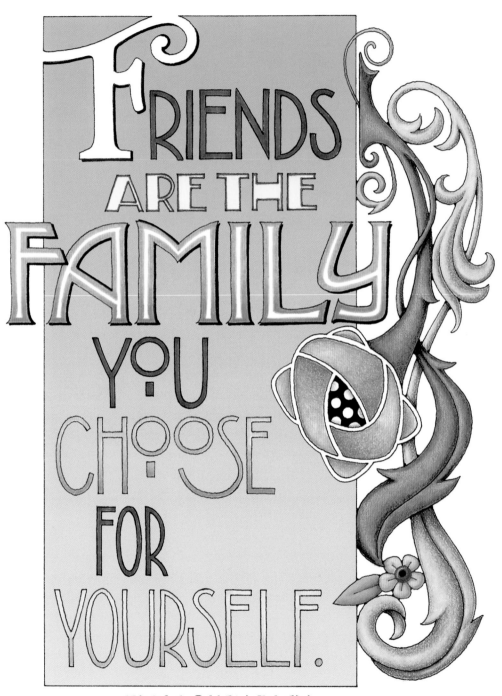

FRIENDS ARE THE FAMILY YOU CHOOSE FOR YOURSELF.

EDNA BUCHANAN

friendship

No one does friendship like Mary Engelbreit. Whether it's an image of freshly blooming affection between young girls or the old-shoe comfort of lifelong confidantes, capturing the spirit of true friendship is something that, for Mary, has always come naturally.

Greeting cards on the subject of friendship are always in demand, and Mary has produced more designs with a friendship theme than perhaps any other. Fortunately, she's had no shortage of inspiration. Mary has cultivated many friendships that began in grammar school and are still strong today. In fact, many of the little girls in braids and hair bows that populate her drawings are actually friends from her school days. "Without friends to fill my life," Mary has said, "I would have had no life to fill my art."

Writings on friendship have provided another deep well of inspiration for Mary. One of her recent favorites is a quotation from Emily Dickinson that reads, "I find it shelter to speak to you." To mirror the spareness and simplicity of those words, Mary drew two women in side-by-side beach chairs, protected by the shade of a big blue umbrella, leaning toward each other in close conversation.

The unadorned simplicity of that illustration is more typical of Mary's recent style, and is something, she says, of a return to her earlier form. "For a lot of years, my drawings were just packed with detail, and I think they tended to look a bit cluttered," she says. "Lately, I've really been trying to keep things more simple and focused. And this seems especially appropriate when I'm working with something as intimate and elemental as friendship."

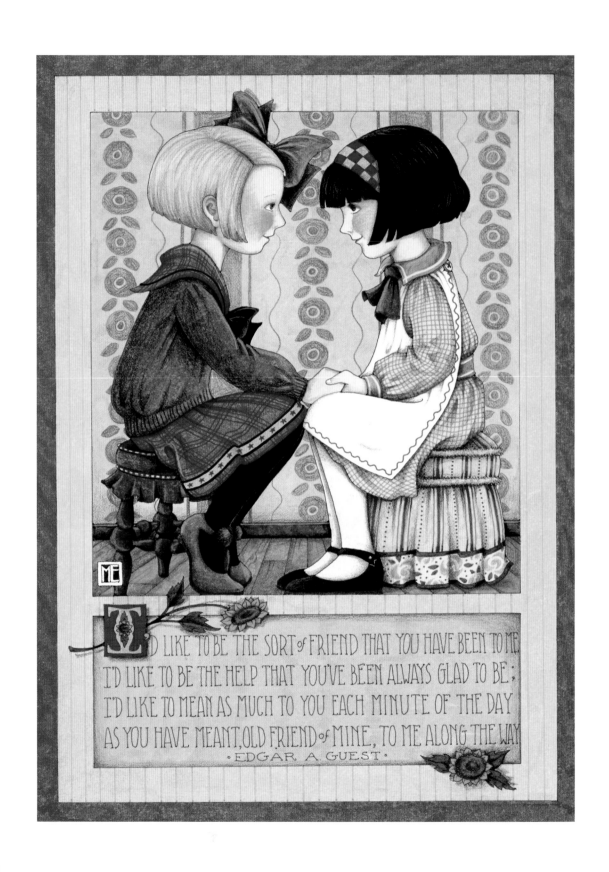

I'D LIKE TO BE THE SORT of FRIEND THAT YOU HAVE BEEN TO ME;
I'D LIKE TO BE THE HELP THAT YOU'VE BEEN ALWAYS GLAD TO BE;
I'D LIKE TO MEAN AS MUCH TO YOU EACH MINUTE OF THE DAY
AS YOU HAVE MEANT, OLD FRIEND of MINE, TO ME ALONG THE WAY.
· EDGAR A. GUEST ·

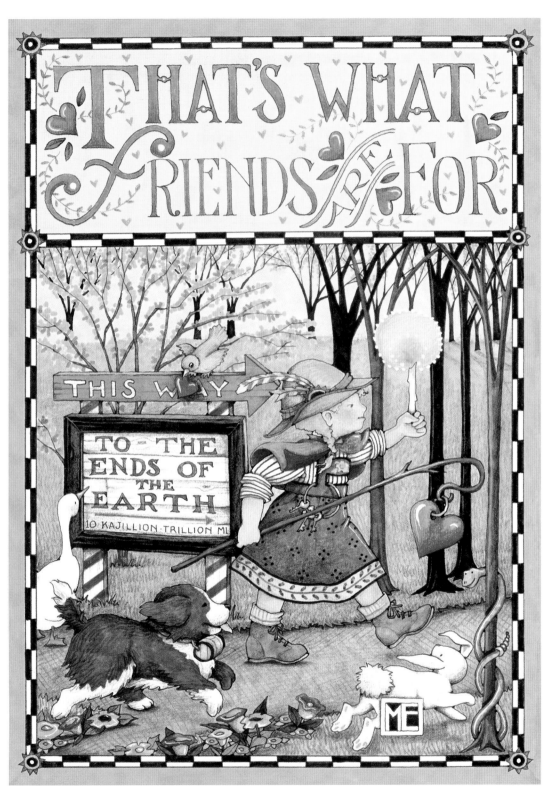

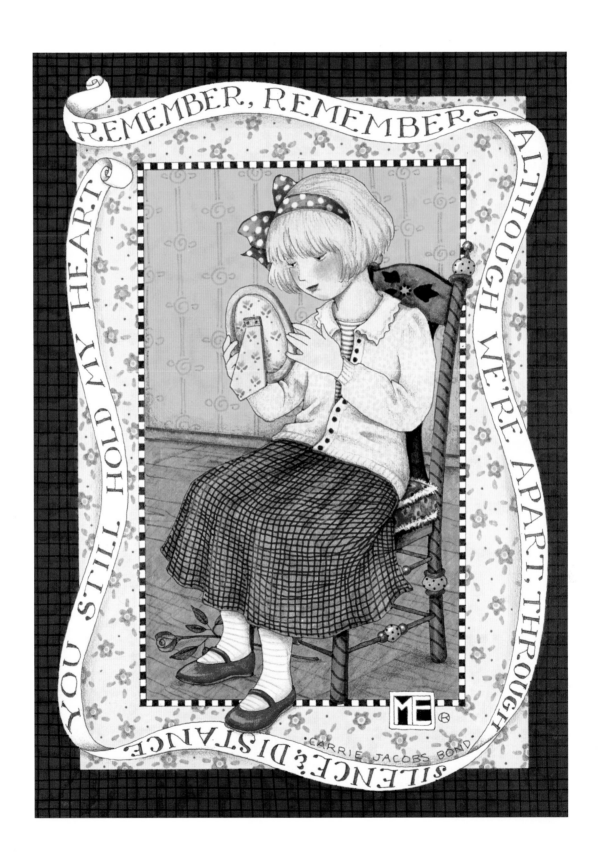

REMEMBER, REMEMBER ALTHOUGH WE'RE APART, THROUGH SILENCE & DISTANCE YOU STILL HOLD MY HEART.

CARRIE JACOBS BOND

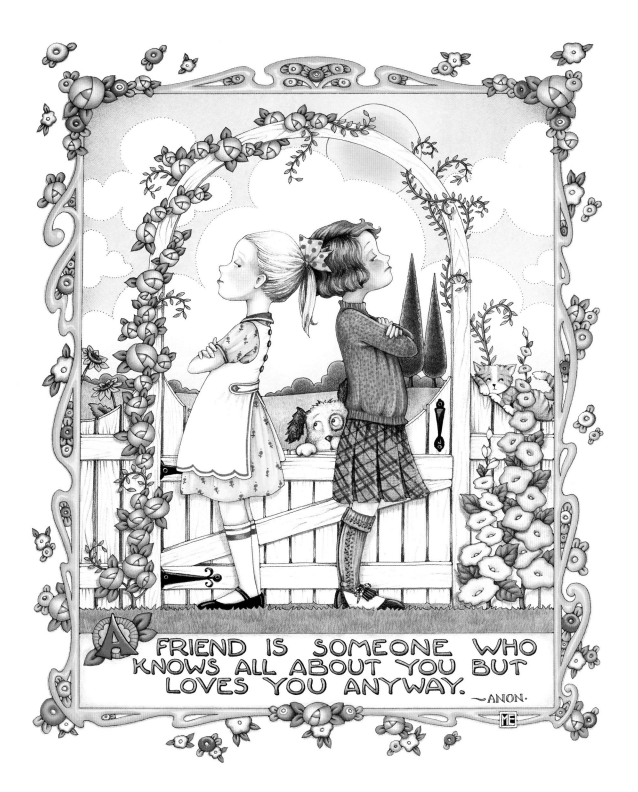

A FRIEND IS SOMEONE WHO KNOWS ALL ABOUT YOU BUT LOVES YOU ANYWAY. ~ANON.

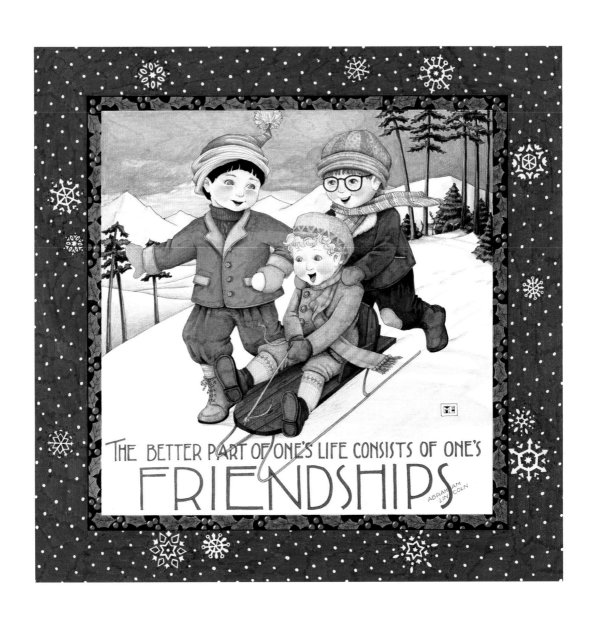

THE BETTER PART OF ONE'S LIFE CONSISTS OF ONE'S

FRIENDSHIPS

ABRAHAM
LINCOLN

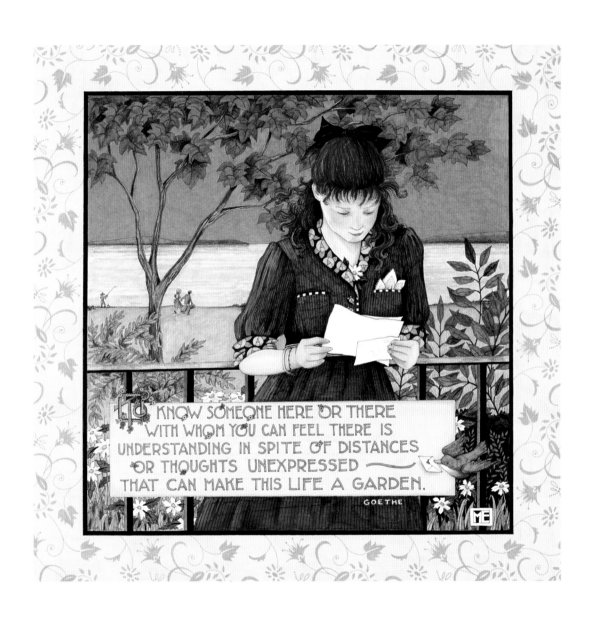

TO KNOW SOMEONE HERE OR THERE
WITH WHOM YOU CAN FEEL THERE IS
UNDERSTANDING IN SPITE OF DISTANCES
OR THOUGHTS UNEXPRESSED —
THAT CAN MAKE THIS LIFE A GARDEN.

GOETHE

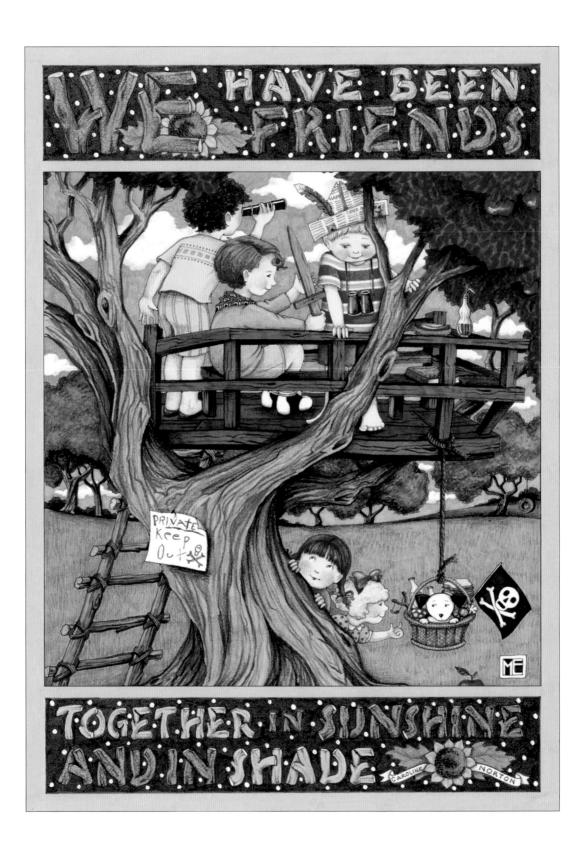

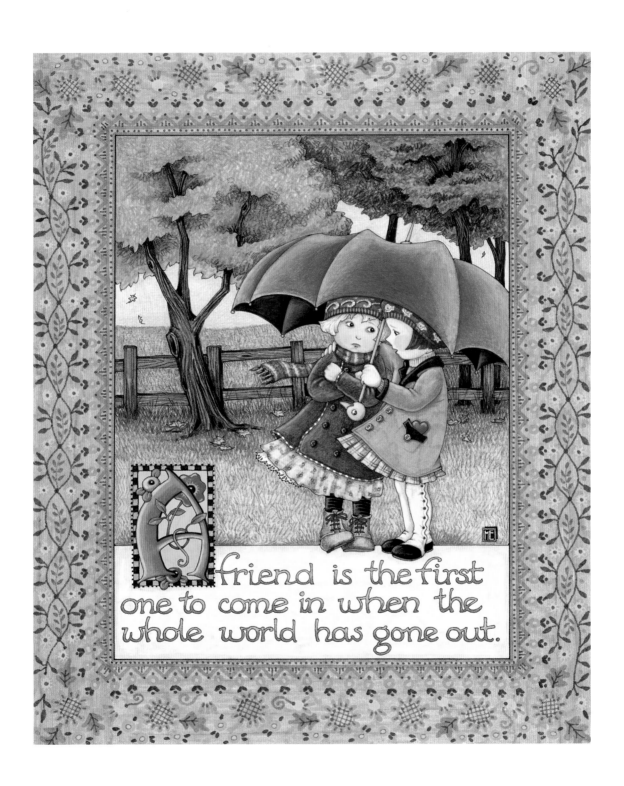

A friend is the first one to come in when the whole world has gone out.

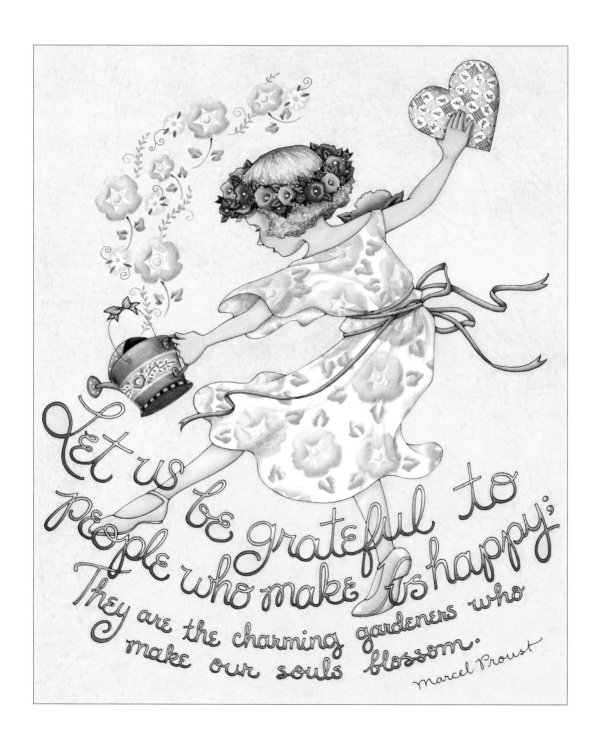

Let us be grateful to people who make us happy; They are the charming gardeners who make our souls blossom.

Marcel Proust

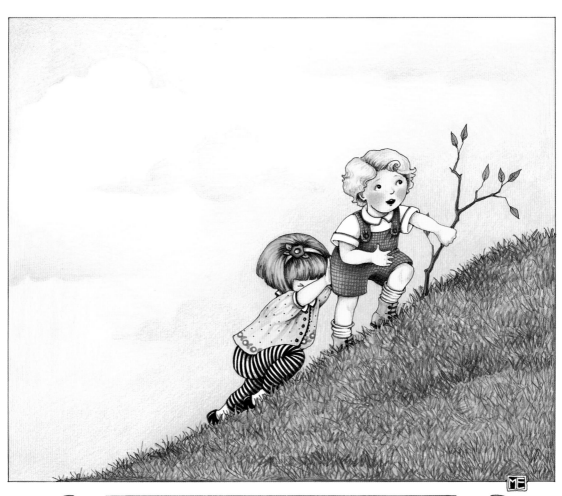

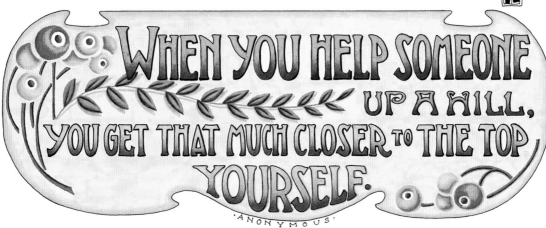

WHEN YOU HELP SOMEONE UP A HILL, YOU GET THAT MUCH CLOSER TO THE TOP YOURSELF.

·ANONYMOUS·

Ah! The Endearing Elegance of Female Friendship!

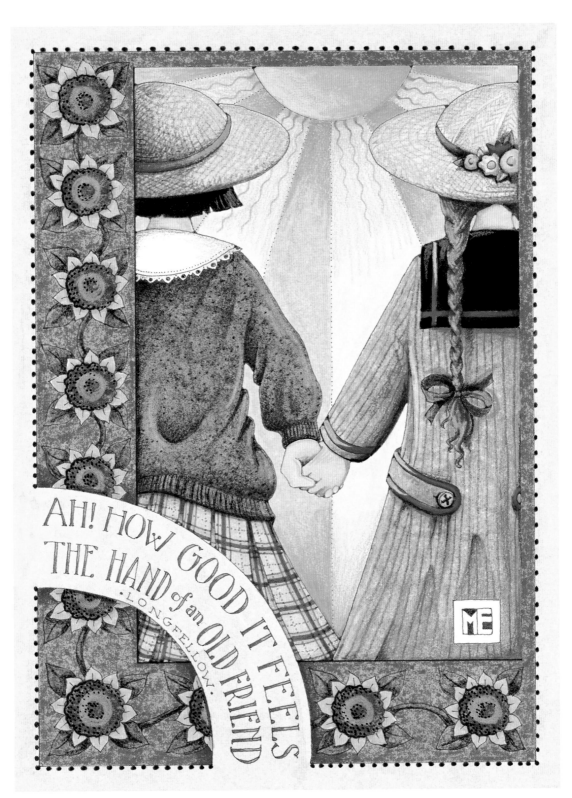

AH! HOW GOOD IT FEELS
THE HAND of an OLD FRIEND
·LONGFELLOW·

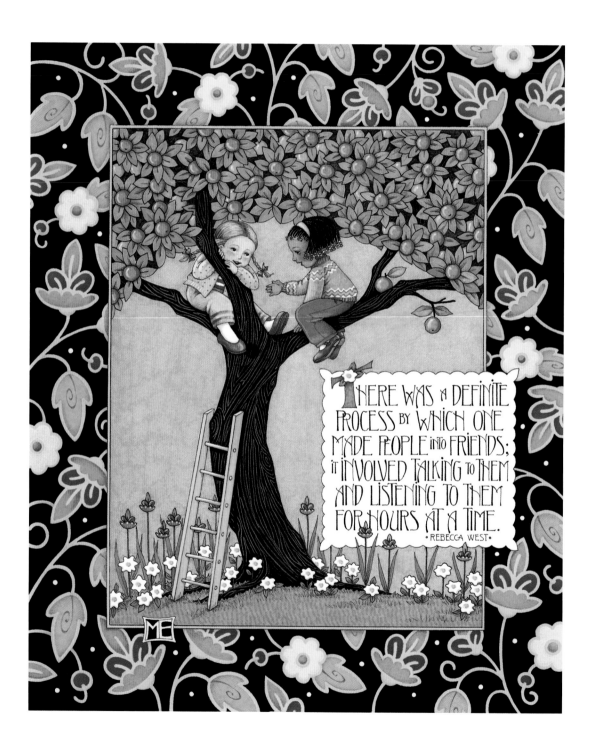

There was a definite process by which one made people into friends; it involved talking to them and listening to them for hours at a time.
• REBECCA WEST •

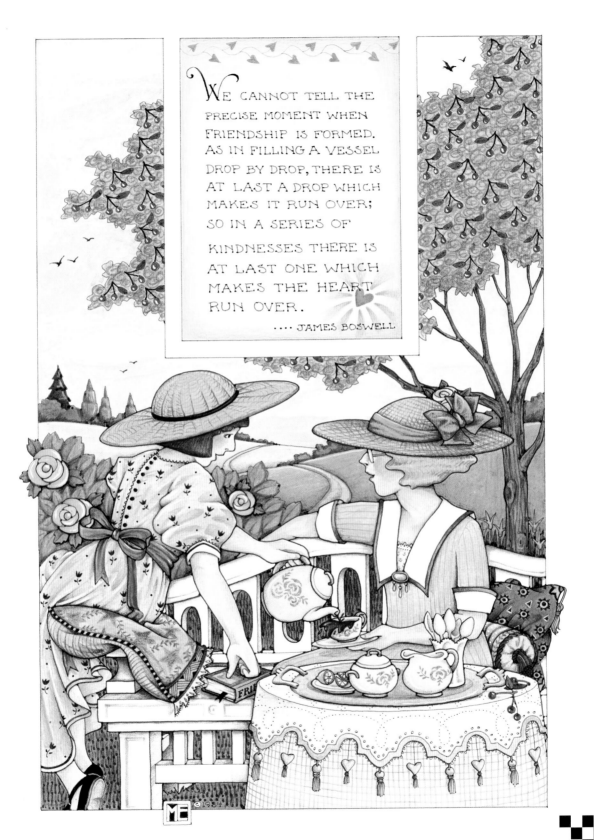

WE CANNOT TELL THE
PRECISE MOMENT WHEN
FRIENDSHIP IS FORMED.
AS IN FILLING A VESSEL
DROP BY DROP, THERE IS
AT LAST A DROP WHICH
MAKES IT RUN OVER;
SO IN A SERIES OF
KINDNESSES THERE IS
AT LAST ONE WHICH
MAKES THE HEART
RUN OVER.

.... JAMES BOSWELL

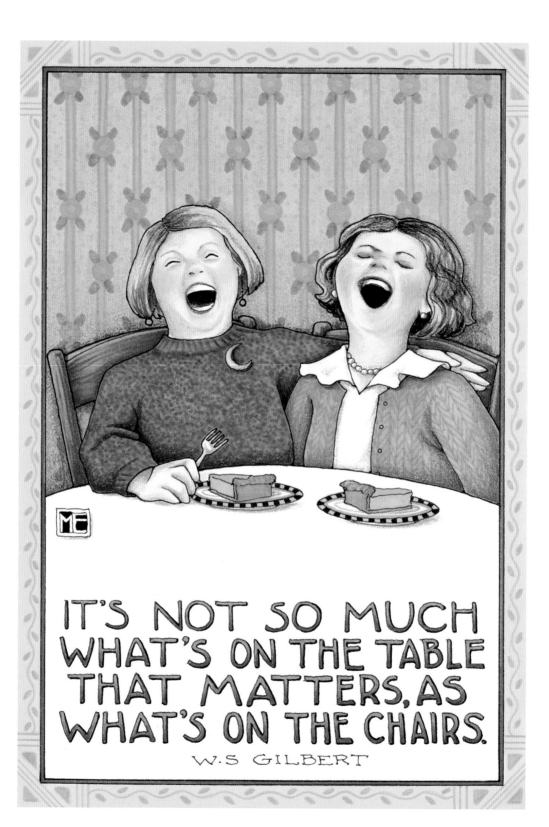

IT'S NOT SO MUCH
WHAT'S ON THE TABLE
THAT MATTERS, AS
WHAT'S ON THE CHAIRS.

W.S GILBERT

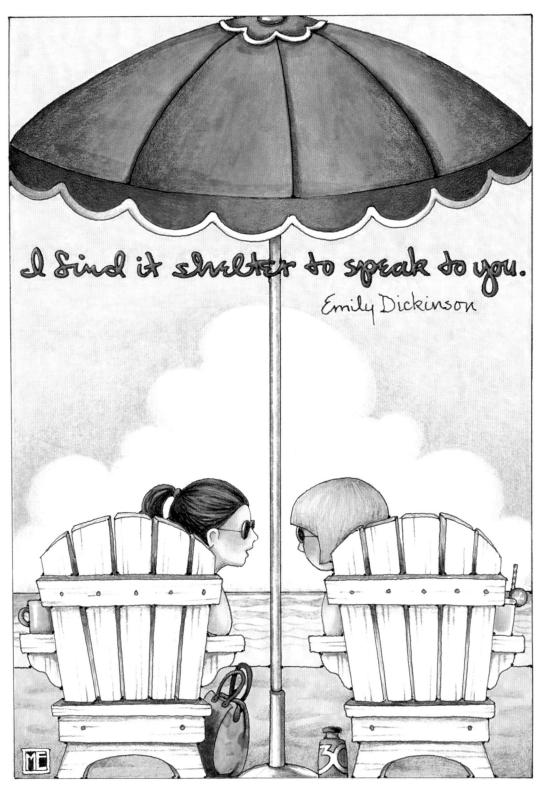

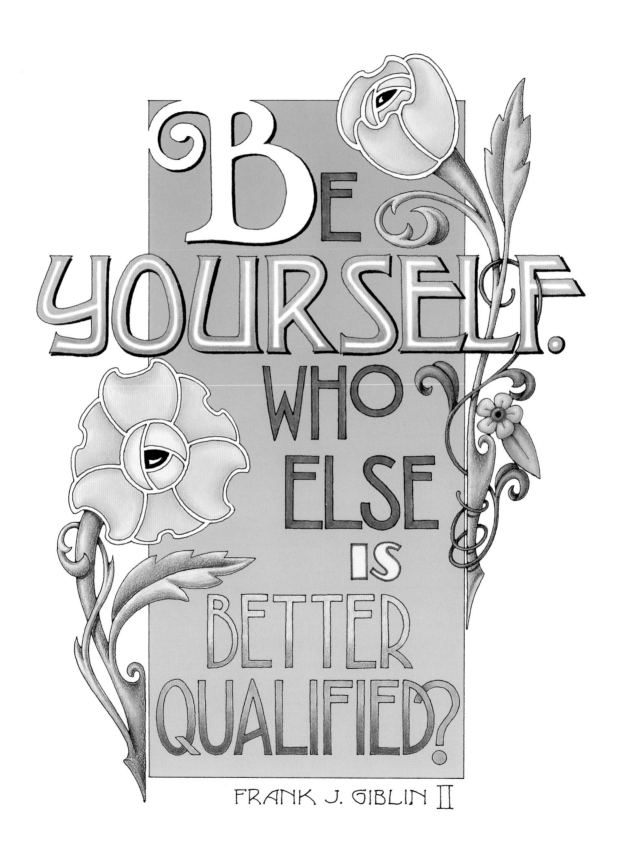

BE YOURSELF. WHO? ELSE IS BETTER QUALIFIED?

FRANK J. GIBLIN II

inspiration

ralph Waldo Emerson, Henry David Thoreau, Marcel Proust . . . the words of some serious thinkers and writers turn up in Mary Engelbreit's illustrations. They are words that, were it not for the fact that they were illustrated by Mary, some people may never see. This observation pleases her greatly. Mary once illustrated a quote by writer Margaret Fuller that read, "If you have knowledge, let others light their candles at it." It's a precept that Mary believes in sincerely. Passing along the inspiring words from some of literature's brightest lights is, after all, an excellent way to "light the candles" of others.

"When I come across writing that really moves me and inspires me, my reaction is two-fold," Mary says. "I want to share it with others and I want to draw something that is worthy of it."

She is drawn especially to writing that is both wise and fresh in spirit. "When I was getting started with greeting cards," she remembers, "in the rare cases where quotations were used, they were often really trite—the same old poem you'd heard a thousand times. I love finding quotes that stop people—that really make them think. And I love the idea that my work, combined with meaningful words, can provide comfort or inspiration to someone."

Some of Mary's most popular illustrations include unattributed quotations. In these cases, the author is either unknown or Mary has pulled the words from somewhere in her subconscious. She refuses to claim credit for such quotes, pointing out that they were probably uttered first by a friend or picked up somewhere along the way. "Time flies . . . whether you're having fun or not" is something Mary and her friends were fond of saying to each other back in her earliest days in business. Who coined the phrase? No one really knows. But, like so many others, once Mary put her pens to it, it became all hers.

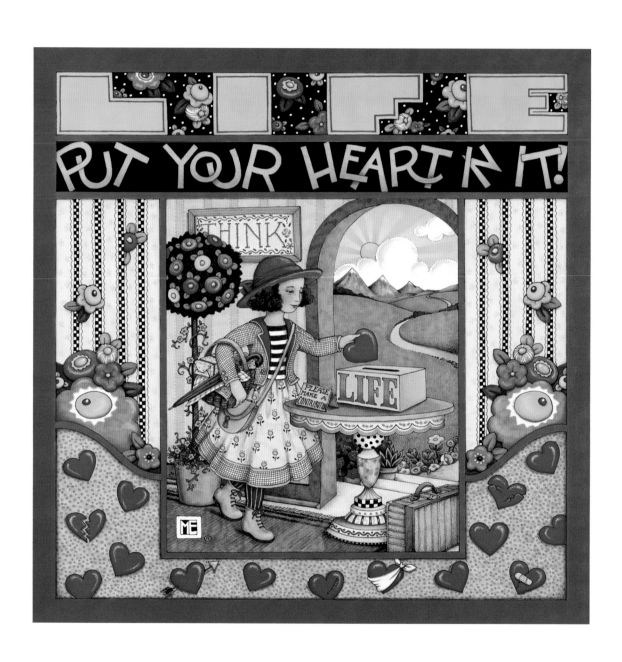

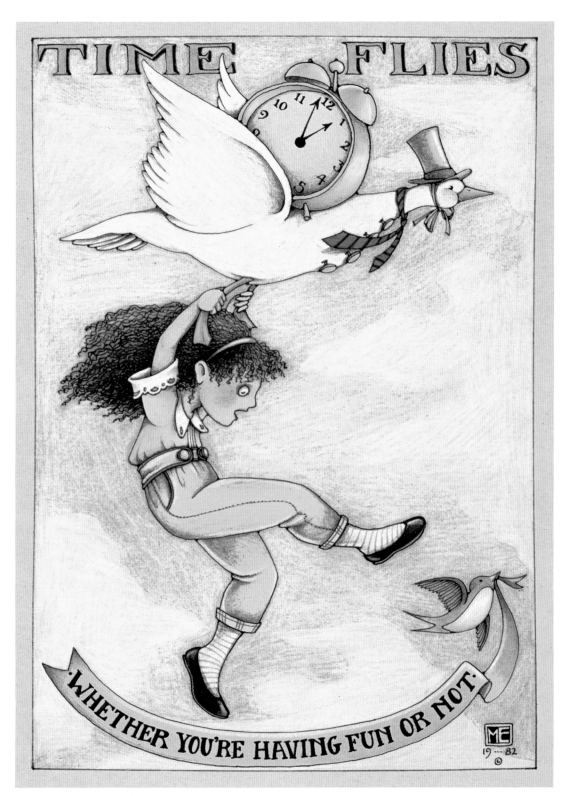

from me to you

This is an old saying I first heard from my mother.

She loved quotations, too. When I got around to illustrating it,
I tried to think of something I really hated to do—like clean—
and I tried to make it look like it was fun. (Which of course, it isn't.)
Unlike me, my mom was a great cleaner and she always tried to tell me
how important it was to learn to do it well.

She never really succeeded.

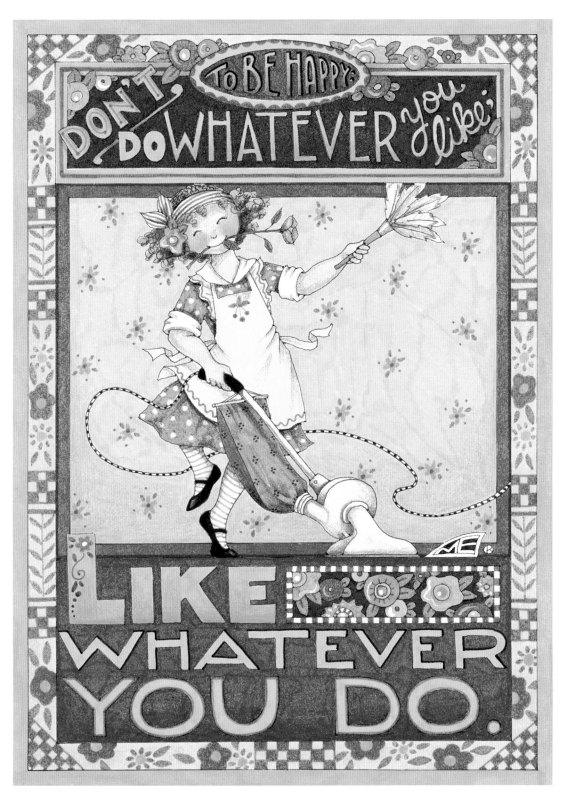

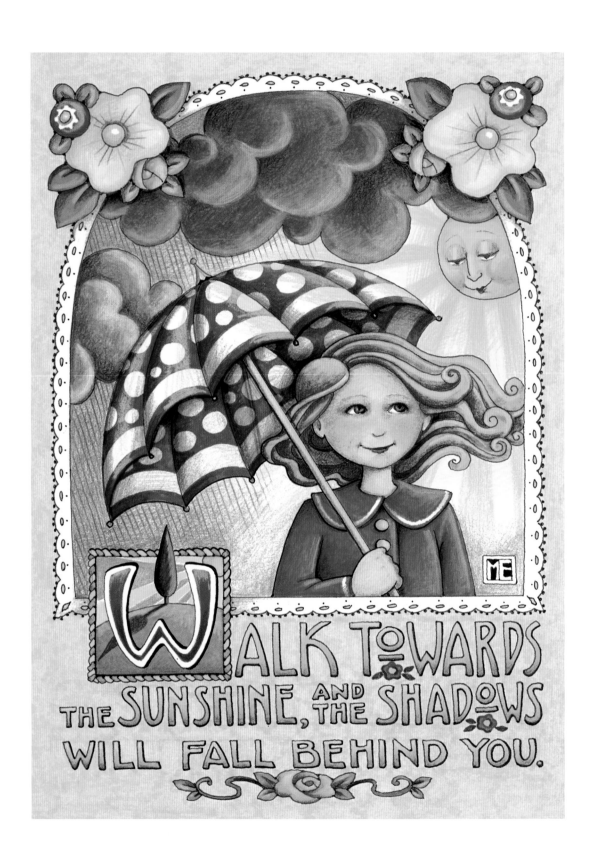

WALK TOWARDS THE SUNSHINE, AND THE SHADOWS WILL FALL BEHIND YOU.

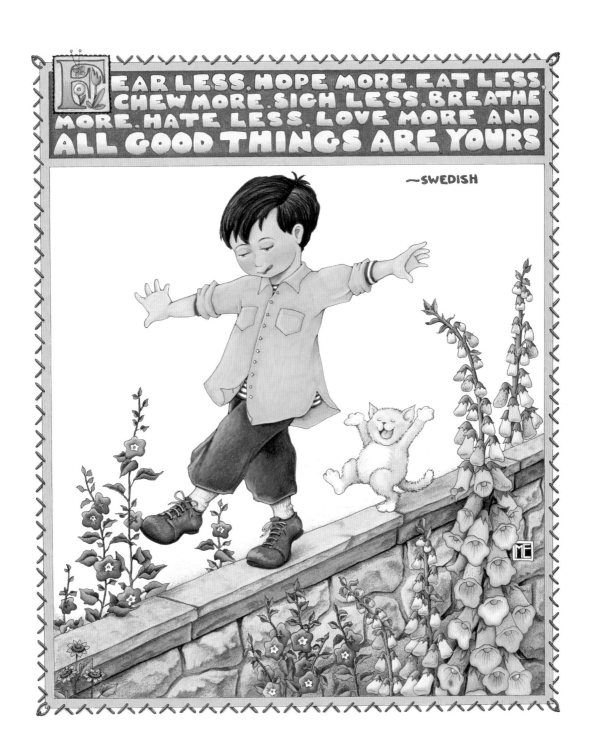

FEAR LESS, HOPE MORE, EAT LESS, CHEW MORE, SIGH LESS, BREATHE MORE, HATE LESS, LOVE MORE AND ALL GOOD THINGS ARE YOURS

~SWEDISH

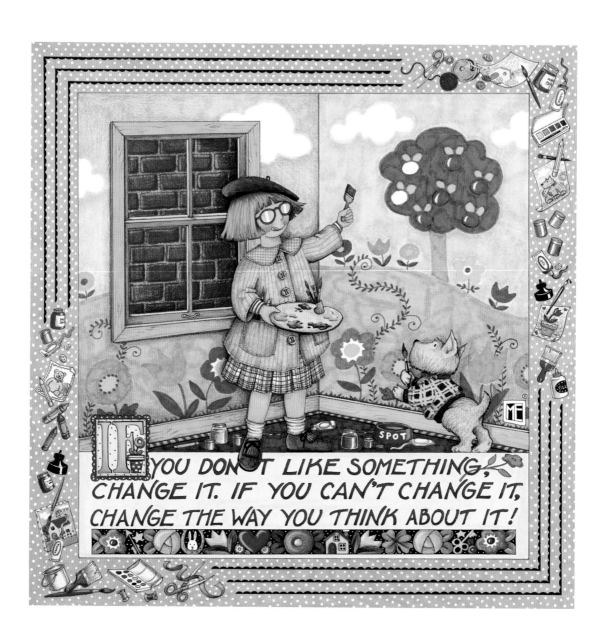

IF YOU DON'T LIKE SOMETHING, CHANGE IT. IF YOU CAN'T CHANGE IT, CHANGE THE WAY YOU THINK ABOUT IT!

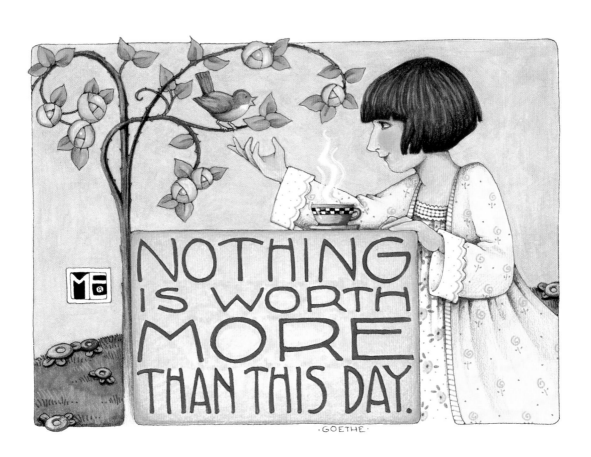

NOTHING IS WORTH MORE THAN THIS DAY.

·GOETHE·

from me to you

This quote makes me think about something I've noticed
about my son's generation.
It seems that lots of people who are finished with school
and kind of finding their way now are kind of waiting
to become rich or famous—and even expecting that it will happen—
but not doing anything to make it happen.
Waiting around for life to begin never works;
you've got to take that leap.

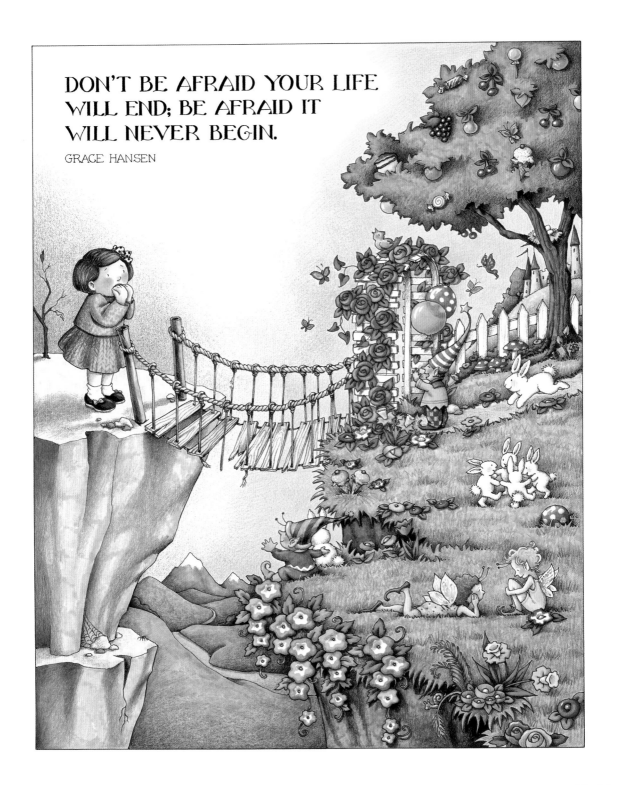

DON'T BE AFRAID YOUR LIFE
WILL END; BE AFRAID IT
WILL NEVER BEGIN.

GRACE HANSEN

64

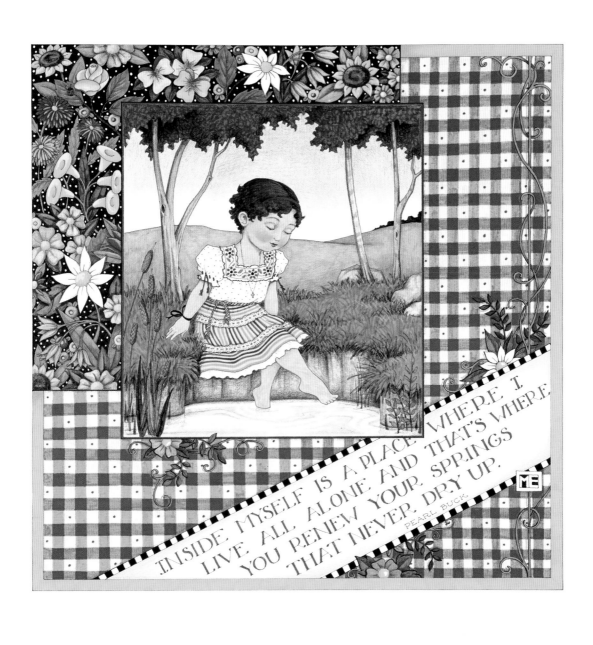

INSIDE MYSELF IS A PLACE WHERE I LIVE, ALL ALONE AND THAT'S WHERE YOU RENEW YOUR SPRINGS THAT NEVER DRY UP.

PEARL BUCK

from me to you

This is such an encouraging thought and a great thing to remember.
Why a roller-skater?
Well, I wanted to show a girl who was all banged up but still trying,
and I did NOT want to draw a bike.
Bikes are really a pain to draw ... all those spokes.
My goal is to never have to draw another one.

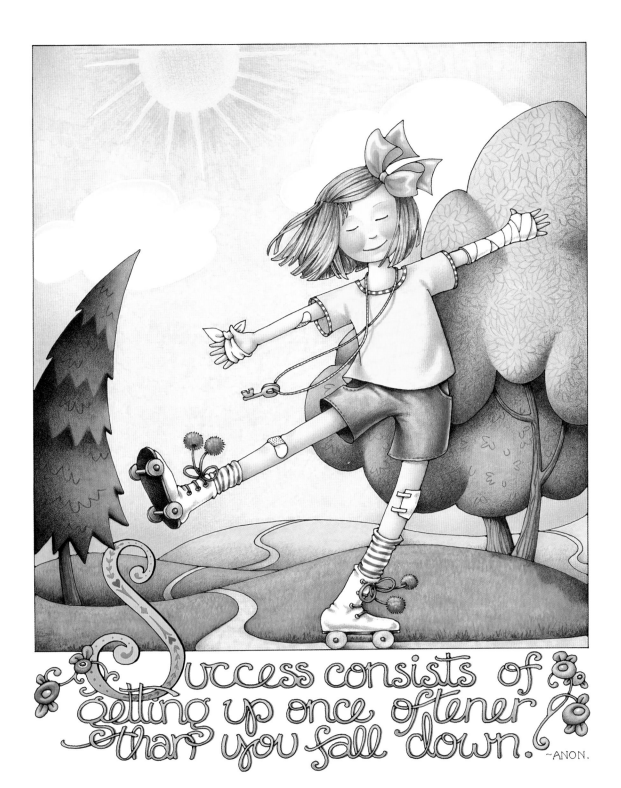

Success consists of getting up once oftener than you fall down. ~ANON.

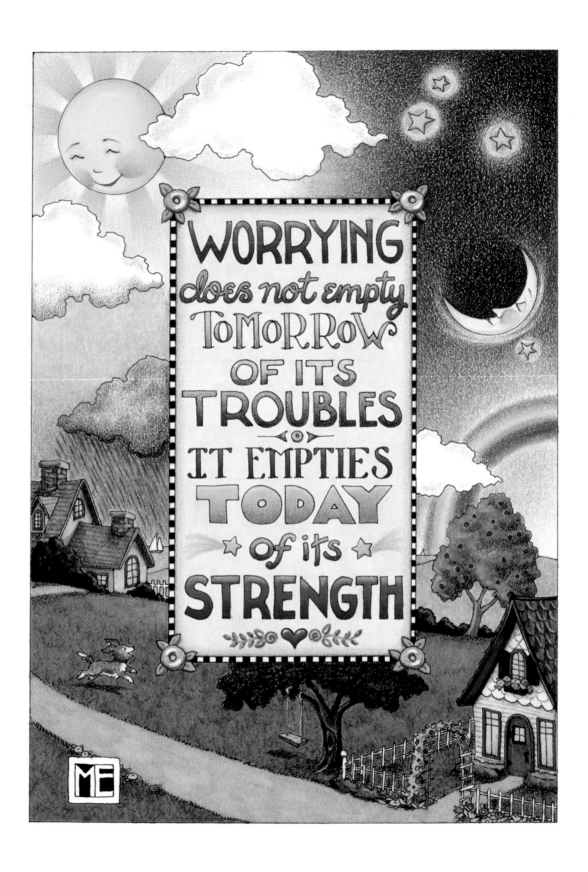

from me to you

I've always loved this quote for its simplicity and directness.
I illustrated this when I was starting to build my business.
It strikes me now as kind of funny that I chose to draw
a mountain climber with this huge obstacle in front of him.
I've gone on exactly one hike in my life and it was the absolute
hardest thing I've ever done,
so I guess that's why I chose a mountain to represent a great challenge.

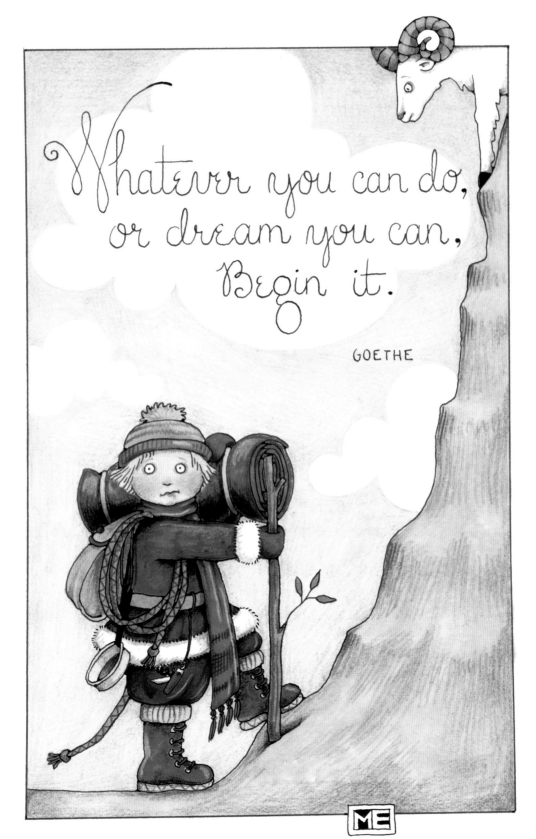

Whatever you can do,
or dream you can,
Begin it.

GOETHE

from me to you

I drew this a long, long time ago.
I wish I could remember if there was something
that made me draw it but I can't.
I do remember that when I was working on the sign in the drawing,
I had written "Your Life" for the direction the kid was going
but was having trouble thinking of what to write for the other direction.
My husband, Phil, actually came up with "No longer an option."
He reminds me of that every chance he gets.
I certainly believe in the sentiment "Don't look back."
I mean, why bother?

73

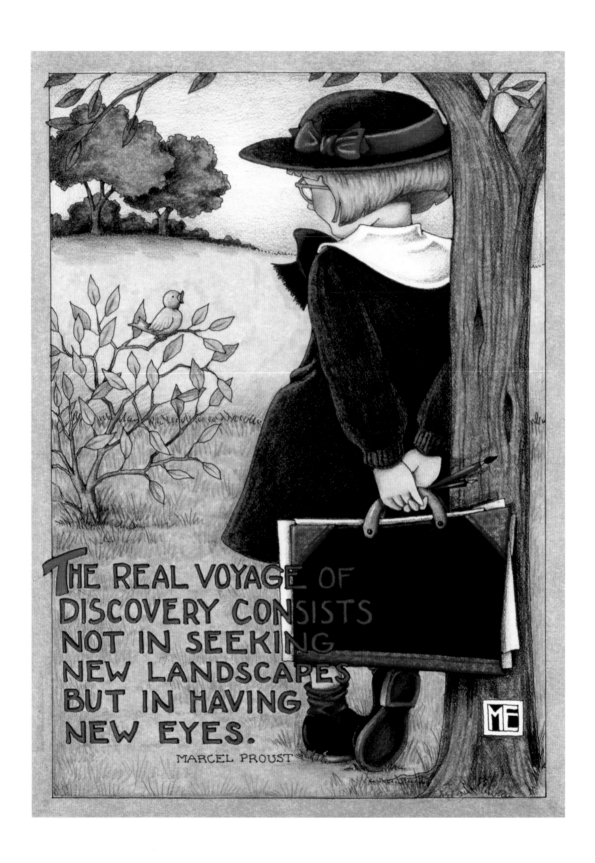

THE REAL VOYAGE OF DISCOVERY CONSISTS NOT IN SEEKING NEW LANDSCAPES BUT IN HAVING NEW EYES.

MARCEL PROUST

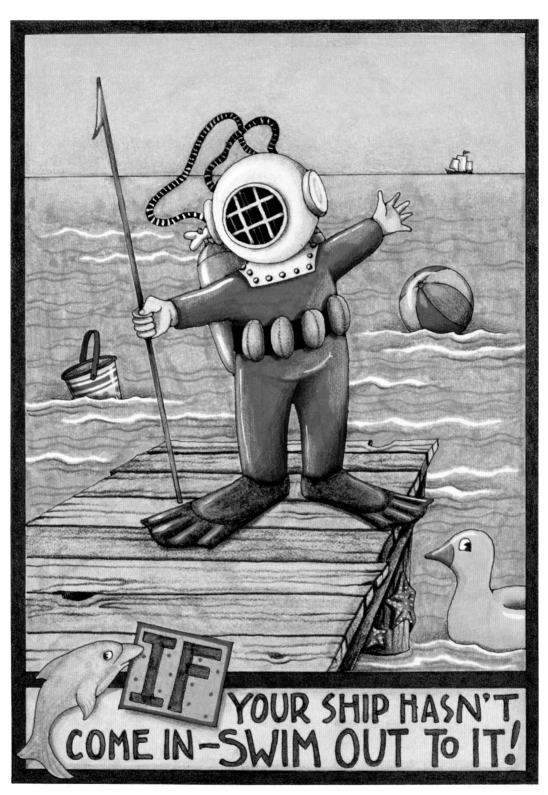

from me to you

I can't remember the circumstance specifically,
but I'm sure I did this when I *was* at the end of my rope.
The thing I like best about this drawing are all those little monsters.
I don't get to draw monsters very often.

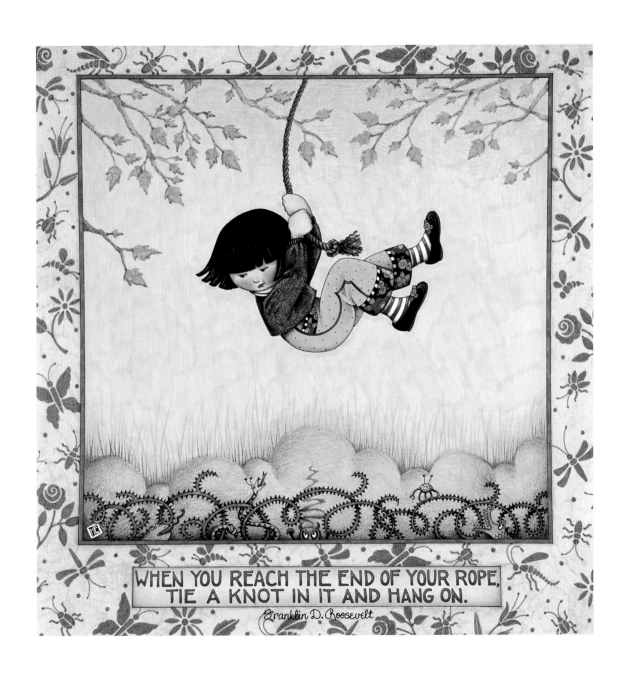

WHEN YOU REACH THE END OF YOUR ROPE,
TIE A KNOT IN IT AND HANG ON.

Franklin D. Roosevelt

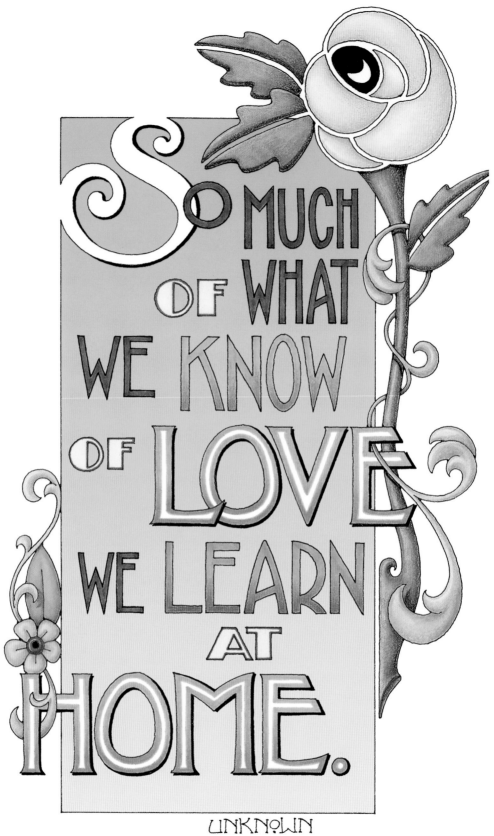

So much of what we know of LOVE we learn at HOME.

UNKNOWN

love and family

Mary's work has always spoken to the heart. And at the heart of her work has always been a love of family. Her own sisters, mother, and father have made appearances in her illustrations—sometimes as themselves and sometimes thinly disguised. Her father was once memorably depicted as a kindly papa bear in a drawing captioned, "I Love You, You Old Bear."

But starting her own family proved to be an even greater creative wellspring. Before having children, a fantasy element filled much of Mary's work. When she became a mother, it instantaneously became more grounded in the everyday as she illustrated the scenes acted out all around her. Toddlers at play in a sandbox, grade school Christmas programs, the serene beauty of a mother comforting a fussy baby—Mary collected them all and over the years many found their way into her drawings.

Mary loves matching favorite quotations on love and family to these intimate images she carries in her subconscious. Coming across a quote from St. Francis De Sales years ago immediately reminded Mary of how it felt watching her husband lift their sleeping son into his bed. "Nothing is so strong as gentleness," reads the quote. "Nothing so gentle as real strength."

Mary's art has always blended romanticism and realism. If she sees the world through rose-colored glasses, she apologizes for it not one bit. She knows there is ugliness in the world, and that it will always get plenty of attention. She would rather concentrate on the positive and the beautiful. One of her drawings illustrates the quote, "A happy family is heaven on earth." In it, a husband and wife serenely read storybooks to their well-kempt children while a cat sleeps contentedly nearby. Yes, she realizes that times like these are few and far between in real families, "But they do happen," she says, "and I like to preserve them in my drawings."

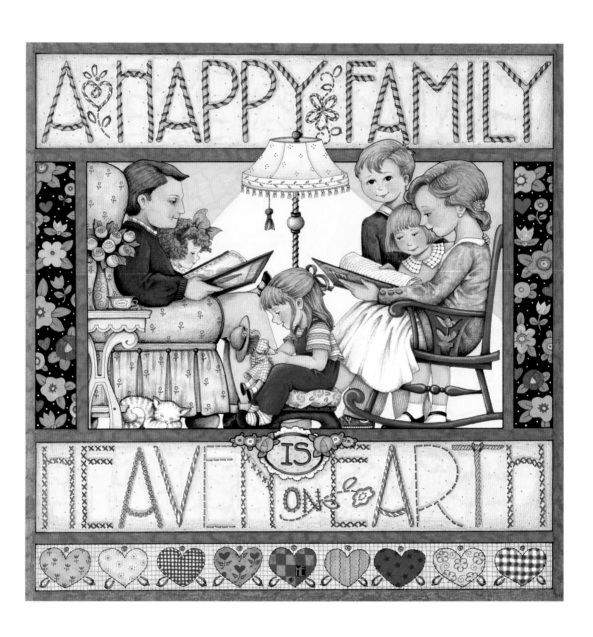

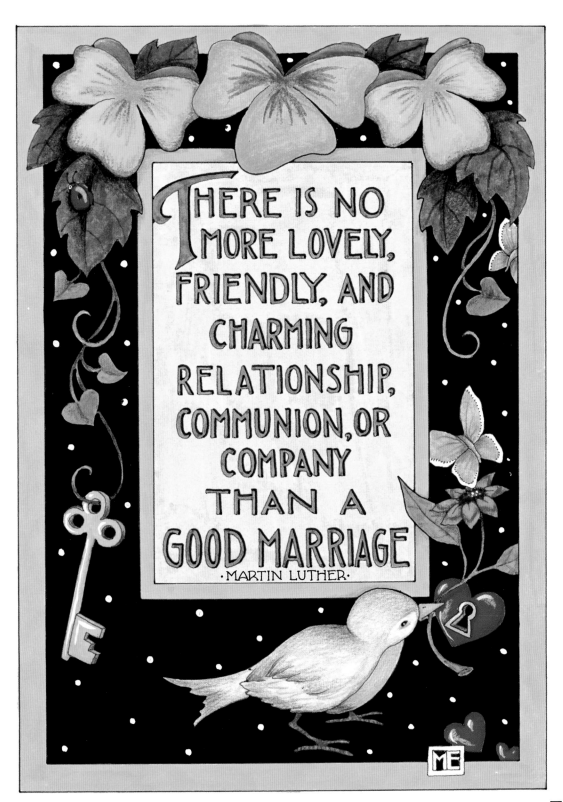

THERE IS NO MORE LOVELY, FRIENDLY, AND CHARMING RELATIONSHIP, COMMUNION, OR COMPANY THAN A GOOD MARRIAGE

·MARTIN LUTHER·

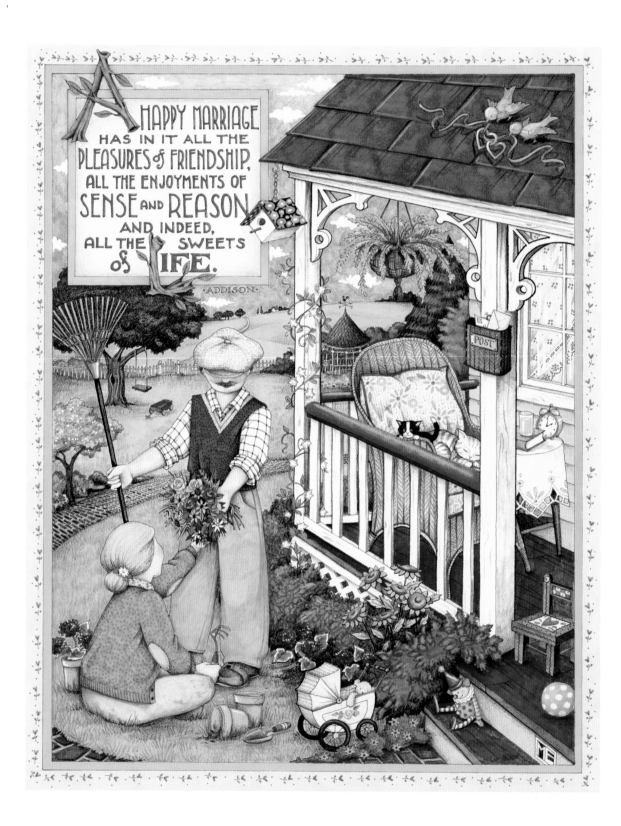

A HAPPY MARRIAGE HAS IN IT ALL THE PLEASURES OF FRIENDSHIP, ALL THE ENJOYMENTS OF SENSE AND REASON AND INDEED, ALL THE SWEETS OF LIFE.

·ADDISON·

84

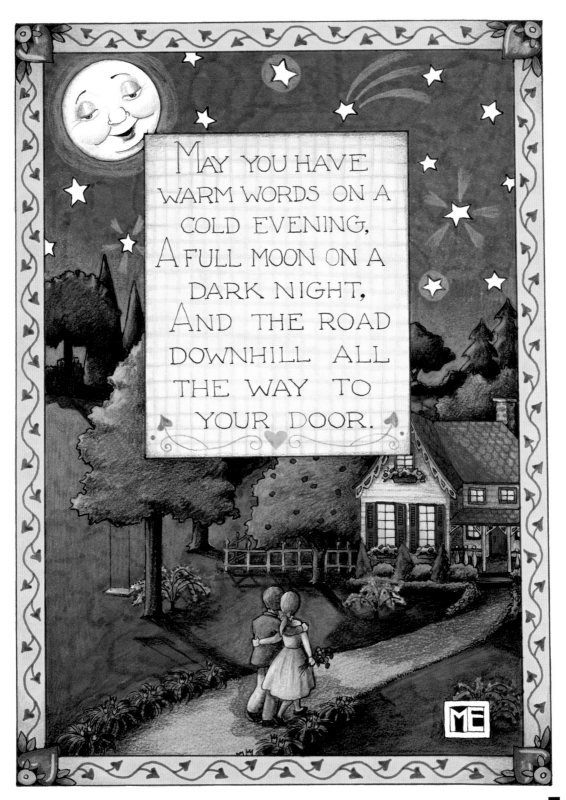

MAY YOU HAVE WARM WORDS ON A COLD EVENING, A FULL MOON ON A DARK NIGHT, AND THE ROAD DOWNHILL ALL THE WAY TO YOUR DOOR.

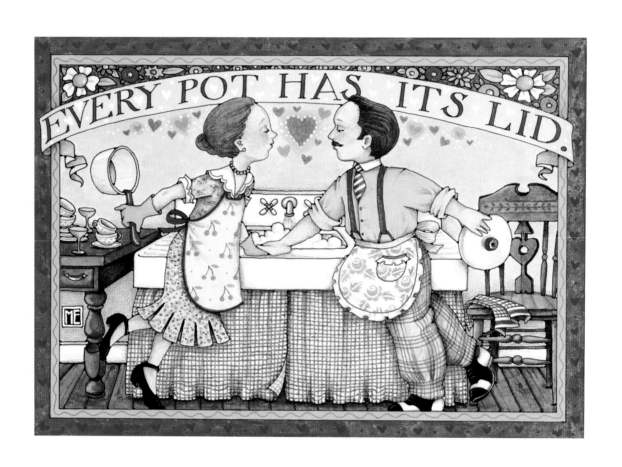

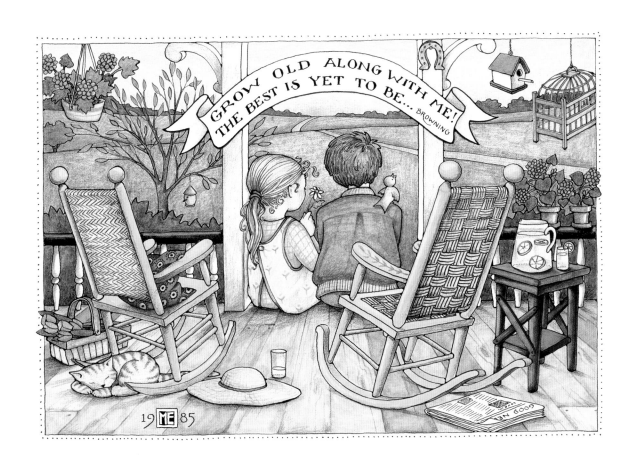

GROW OLD ALONG WITH ME!
THE BEST IS YET TO BE... BROWNING

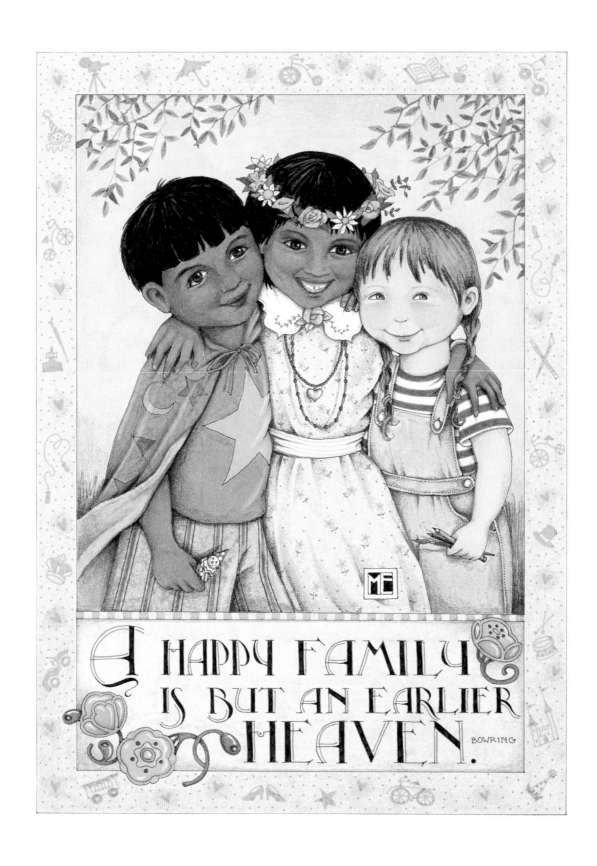

A HAPPY FAMILY IS BUT AN EARLIER HEAVEN. BOWRING.

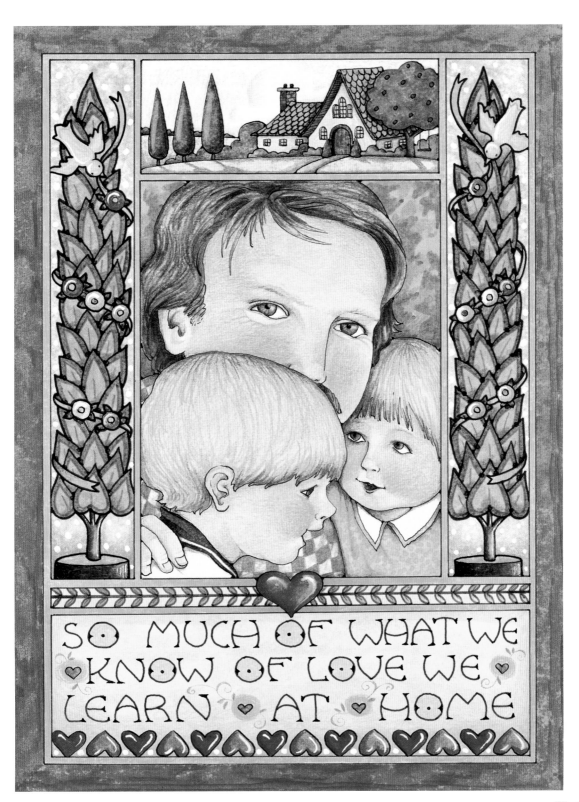

SO MUCH OF WHAT WE KNOW OF LOVE WE LEARN AT HOME

from me to you

I wanted to illustrate this quote because that's how I felt
about my mother when I was a girl.
It seemed to me that she knew exactly
what I would want to do all the time.
She had a great understanding of what we kids would want.
I remember once when *King Kong* was on TV, she said,
"Okay, call everyone in the neighborhood and tell them to come over.
It's a great movie and we'll make fudge and have a party."
She was always having tea parties with all these perfect little touches,
and, of course, the best thing she did was fix up a little closet
in our house as my first studio.
She was never at a loss for something fun to do.
She never got to see it, but this one was for Mom.

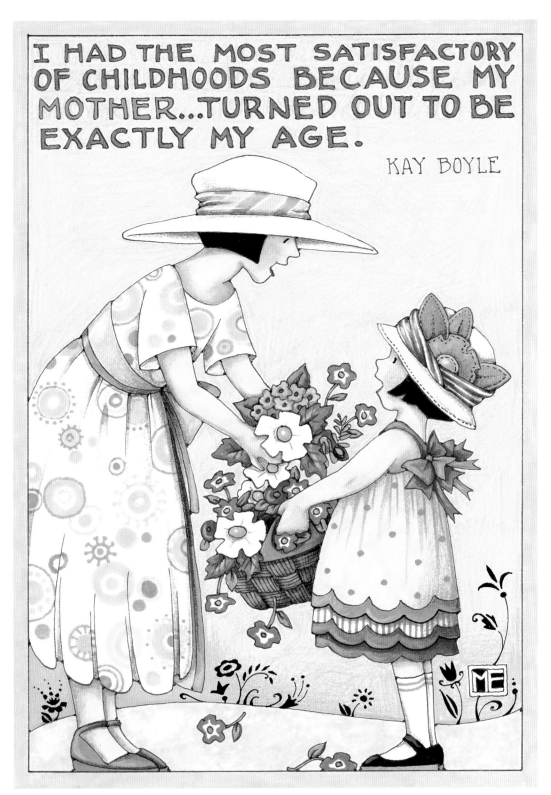

I HAD THE MOST SATISFACTORY OF CHILDHOODS BECAUSE MY MOTHER...TURNED OUT TO BE EXACTLY MY AGE.

KAY BOYLE

91

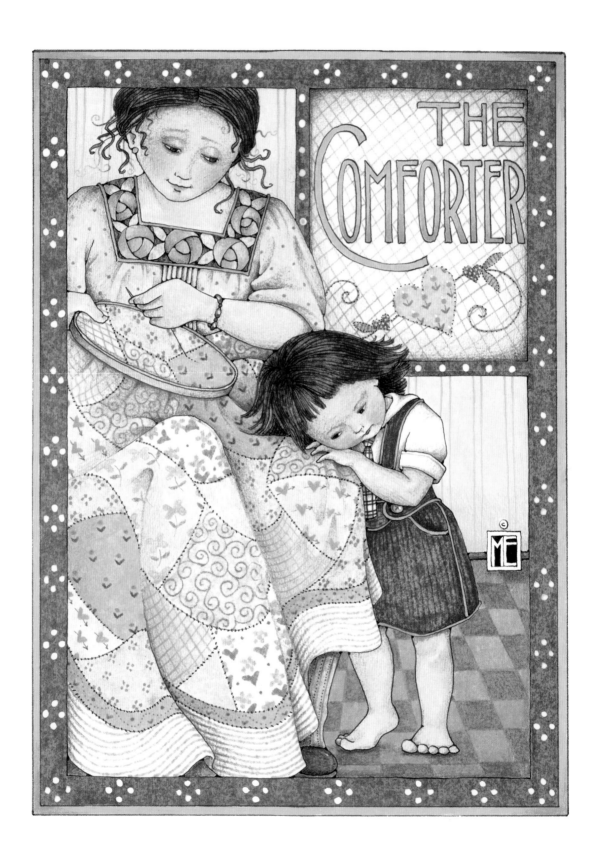

THE
COMFORTER

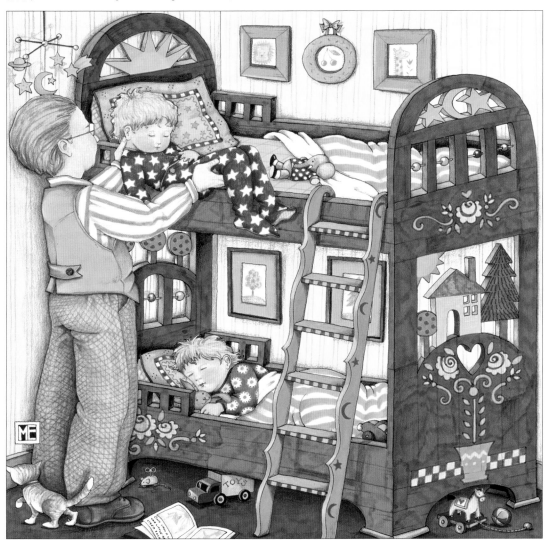

NOTHING IS SO STRONG AS
GENTLENESS;
NOTHING SO GENTLE AS
REAL STRENGTH.

FRANCIS DE SALES

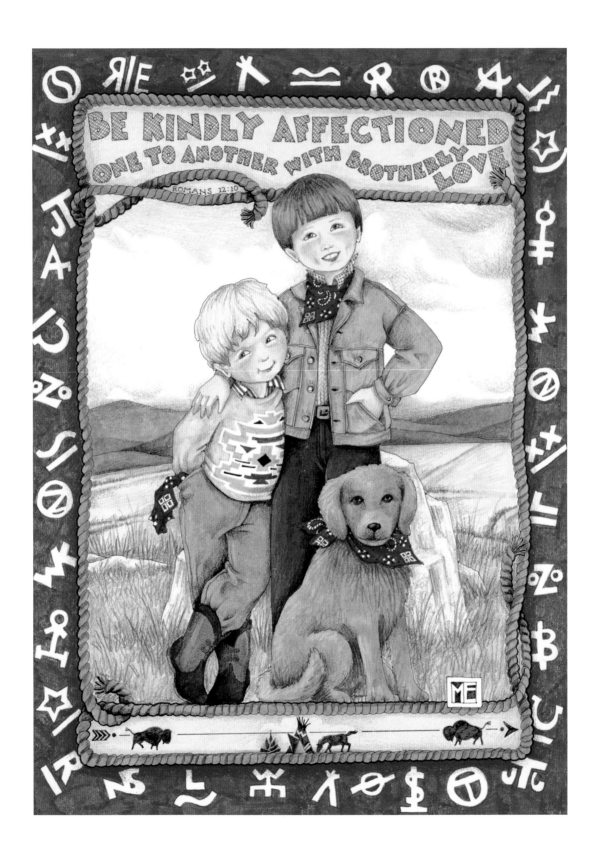

BE KINDLY AFFECTIONED ONE TO ANOTHER WITH BROTHERLY LOVE

ROMANS 12:10

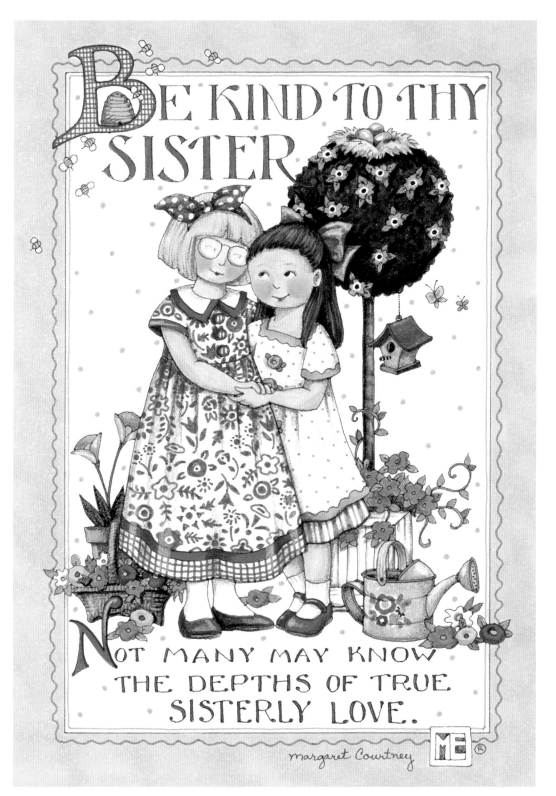

BE KIND TO THY SISTER

NOT MANY MAY KNOW THE DEPTHS OF TRUE SISTERLY LOVE.

Margaret Courtney

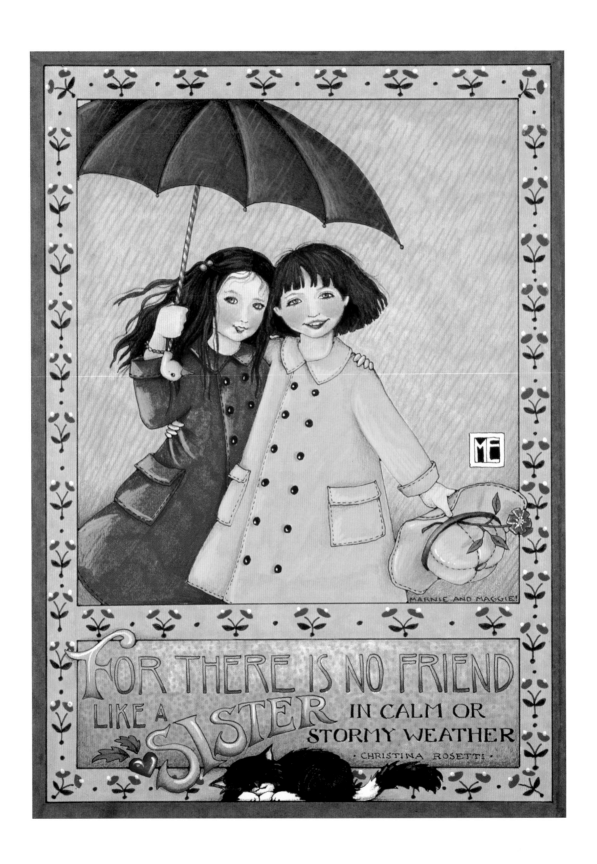

FOR THERE IS NO FRIEND LIKE A SISTER IN CALM OR STORMY WEATHER

· CHRISTINA ROSETTI ·

MARNIE AND MAGGIE!

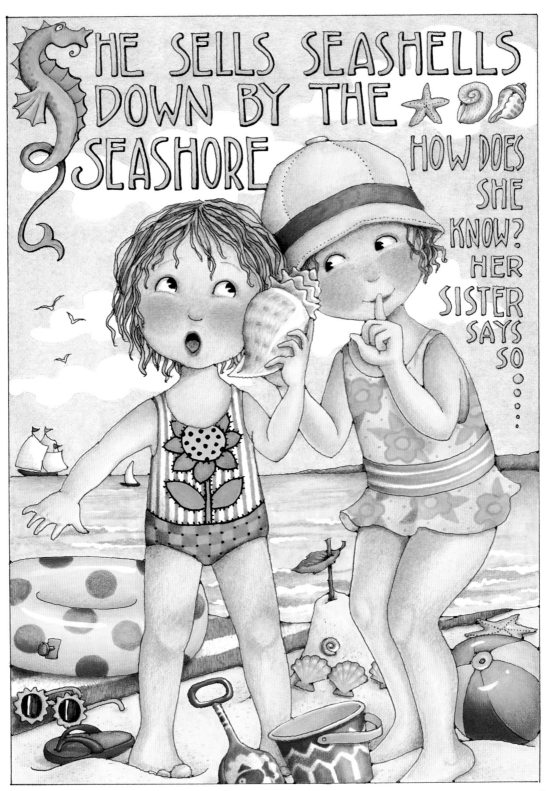

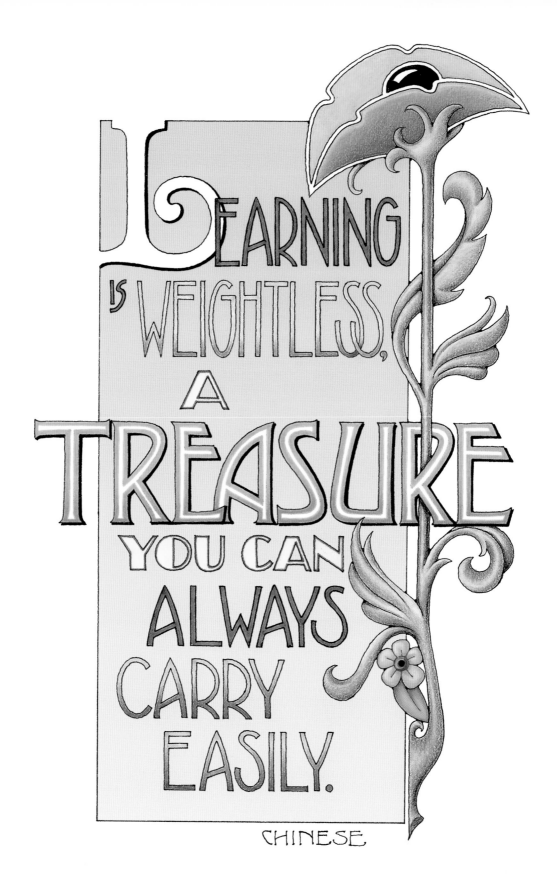

LEARNING IS WEIGHTLESS, A TREASURE YOU CAN ALWAYS CARRY EASILY.

CHINESE

wisdom

Over the years, it's become apparent to Mary Engelbreit that teachers, as a group, are particularly fond of her work. Maybe that's because they sense a certain kinship with this artist who, to be honest, had something of a love/hate relationship with school. And Mary seems to instinctively know one of the golden rules of teaching: Keep your students engaged and entertained, and they'll never realize they're learning.

Mary sneaks her point across by incorporating wise words into whimsical artwork. She knows that while her drawings may grab people's attention, the right words will make them think. And there's lots she wants people to think about: the importance of living in agreement with nature, the true meaning of success, the magic of finding your true passion in life, even the importance of learning itself.

For Mary, it's impossible not to be inspired by some of her most admired authors. A favorite quote from Ralph Waldo Emerson reads "Make the most of yourself, for that is all there is of you." Mary's take on it finds a schoolgirl happily ensconced behind a stack of books. But she also knows that true wisdom often doesn't come from books. Nearly twenty years ago, Mary drew a memorable picture of a tousled-haired young boy completely absorbed by the site of a tiny ladybug crawling on a daisy. The text she selected came from the poet William Wordsworth: "Come forth into the light of things, Let Nature be your teacher."

Such weighty lessons are not easy to distill into words—and in the bustle of a busy world they can be even harder to remember. But Mary's art pulls off the nifty trick of making them unforgettable. Funny how a reluctant student can grow up to be such an effective teacher.

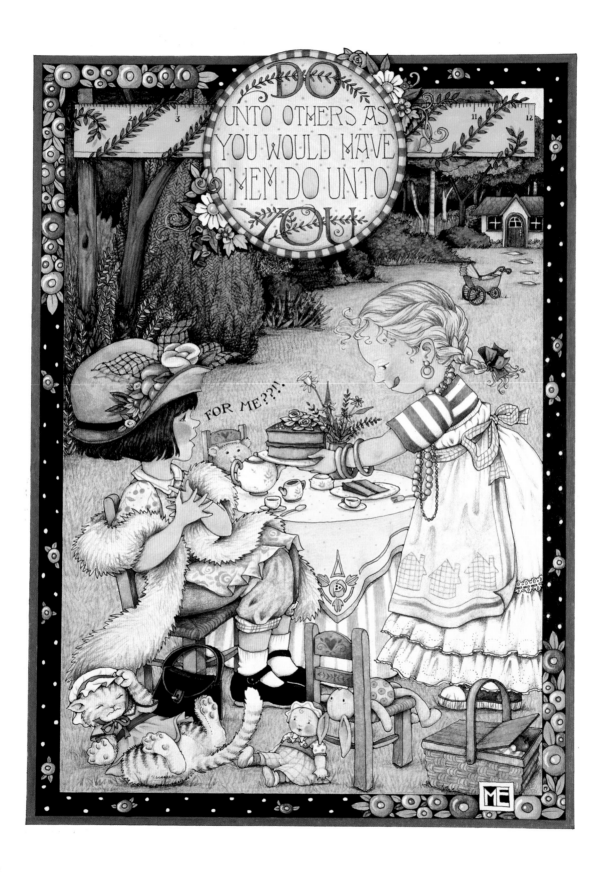

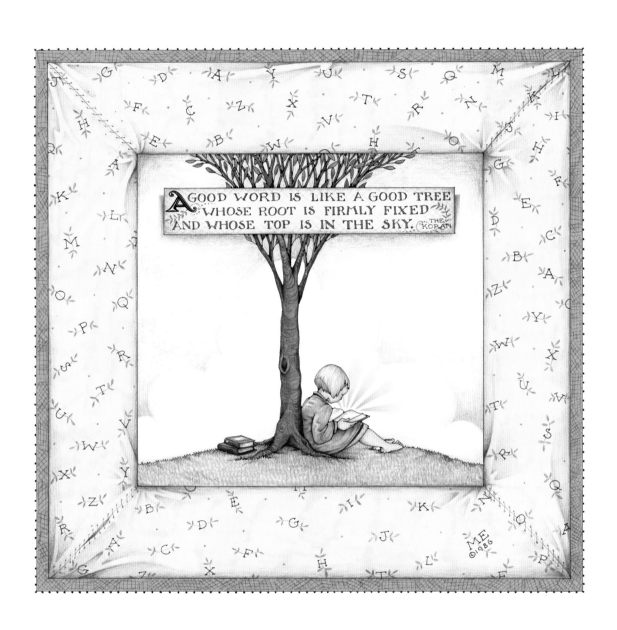

A GOOD WORD IS LIKE A GOOD TREE WHOSE ROOT IS FIRMLY FIXED AND WHOSE TOP IS IN THE SKY. —THE KORAN

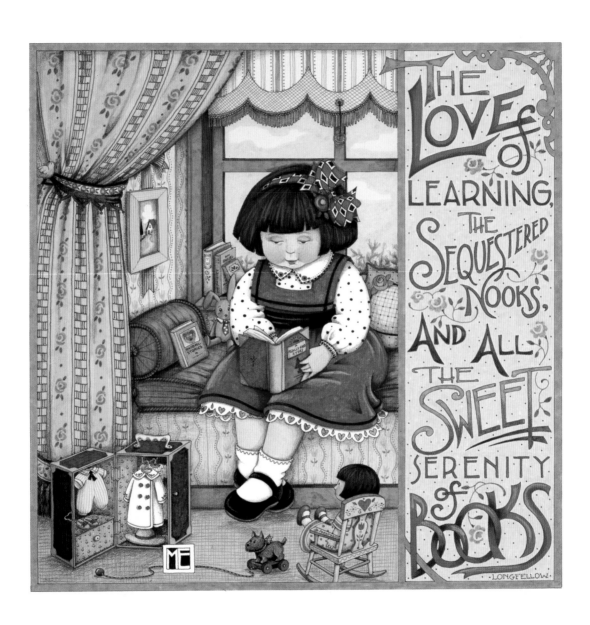

THE LOVE OF LEARNING, THE SEQUESTERED NOOKS, AND ALL THE SWEET SERENITY OF BOOKS

LONGFELLOW

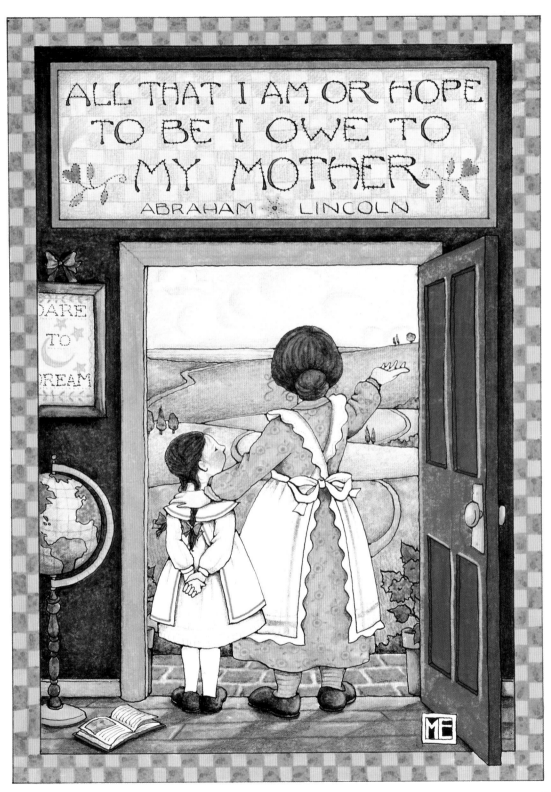

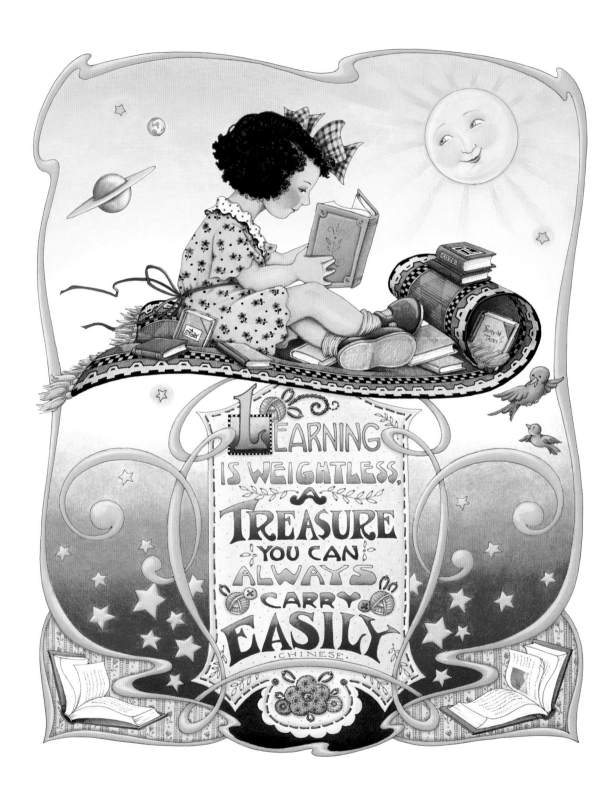

LEARNING IS WEIGHTLESS, A TREASURE YOU CAN ALWAYS CARRY EASILY

·CHINESE·

DON'T LET SUCCESS
GO TO YOUR HEAD OR
FAILURE GO TO YOUR HEART.

~ANONYMOUS~

from me to you

Another old maxim that I really believe in.
Although it wasn't my intention,
this quote kind of became the theme of my *Ann Estelle* books.
Life always gives her lemons but she turns them into a good thing.
After I realized this, I drew this picture to go with the quote.
I really believe that even horrible things that happen
can lead to good things.
They are learning opportunities.

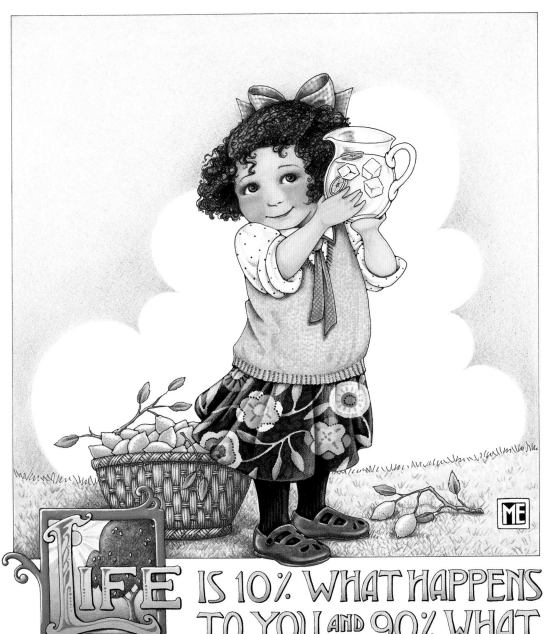

LIFE IS 10% WHAT HAPPENS TO YOU *and* 90% WHAT YOU DO *with* WHAT HAPPENS TO YOU.

~ ANONYMOUS ~

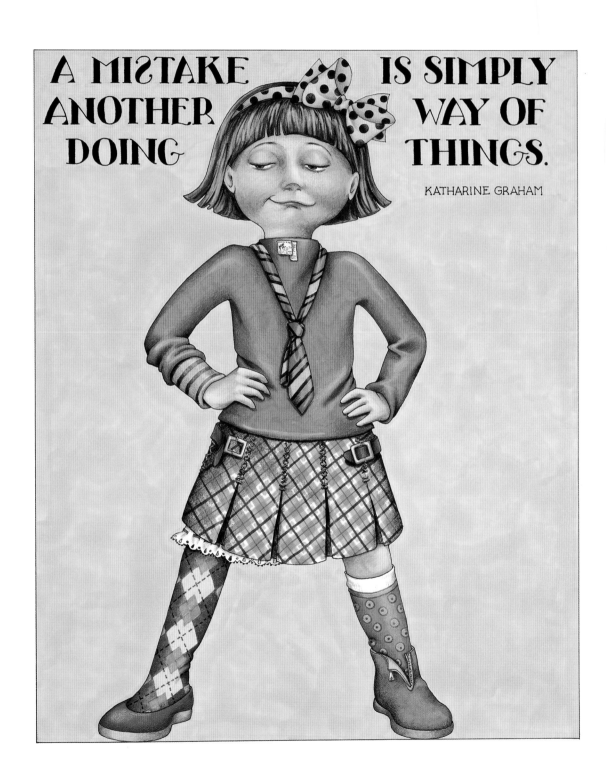

A MISTAKE IS SIMPLY ANOTHER WAY OF DOING THINGS.

KATHARINE GRAHAM

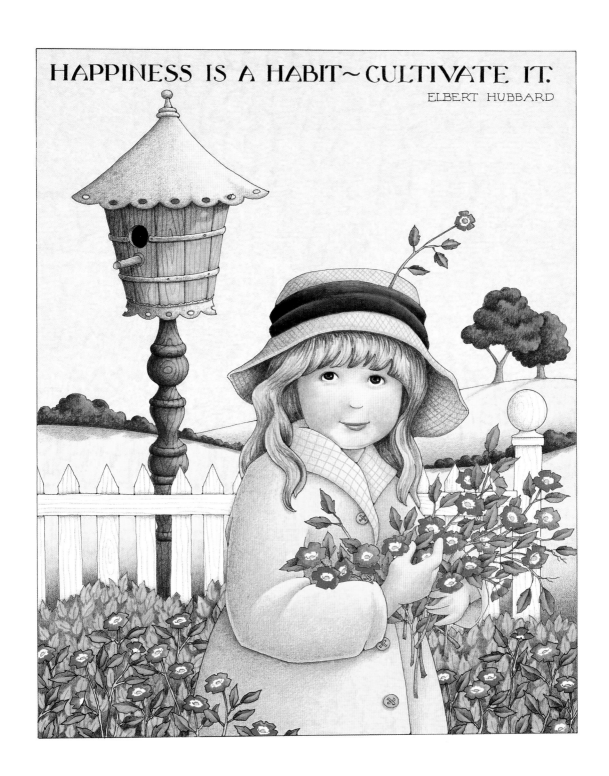

HAPPINESS IS A HABIT~CULTIVATE IT.

ELBERT HUBBARD

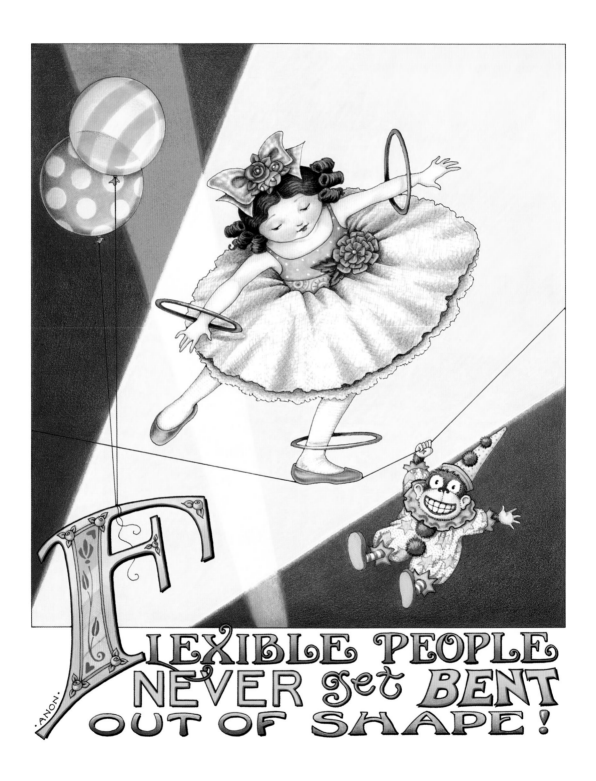

FLEXIBLE PEOPLE NEVER get BENT OUT OF SHAPE!

—ANON.

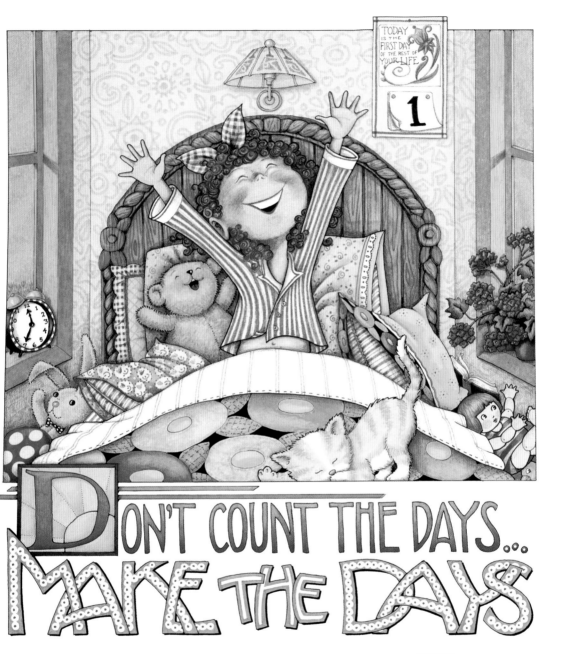

DON'T COUNT THE DAYS...
MAKE THE DAYS
COUNT.

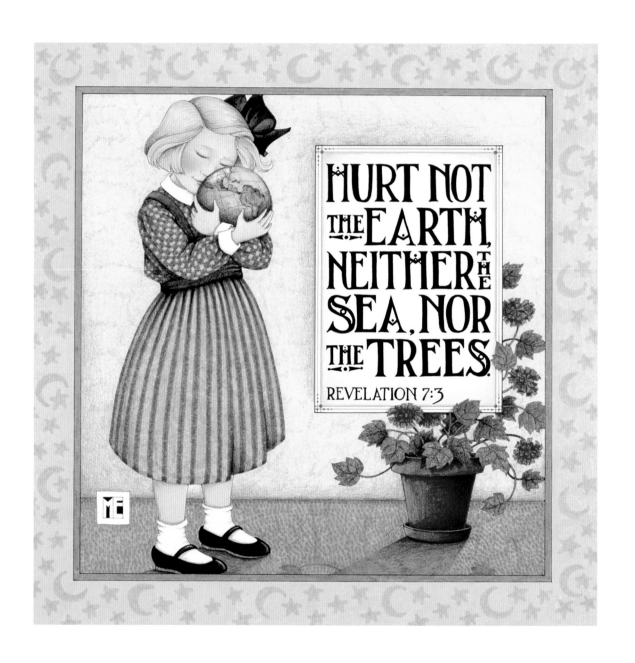

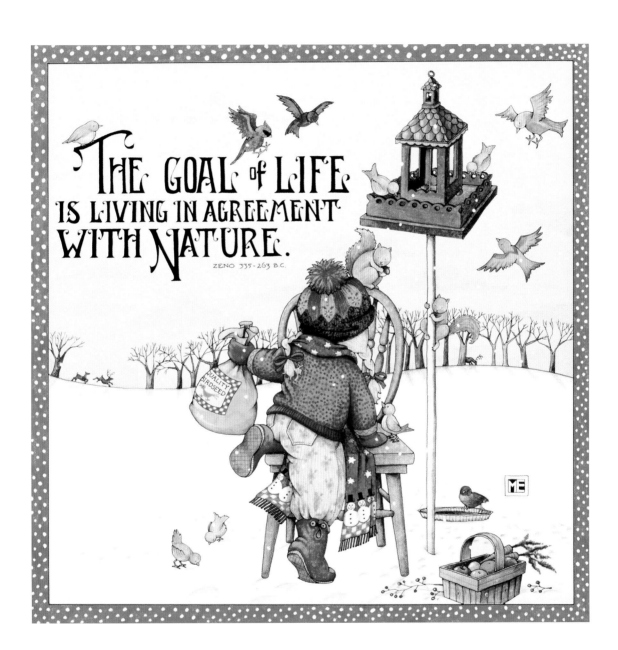

THE GOAL of LIFE IS LIVING IN AGREEMENT WITH NATURE.

ZENO 335-263 B.C.

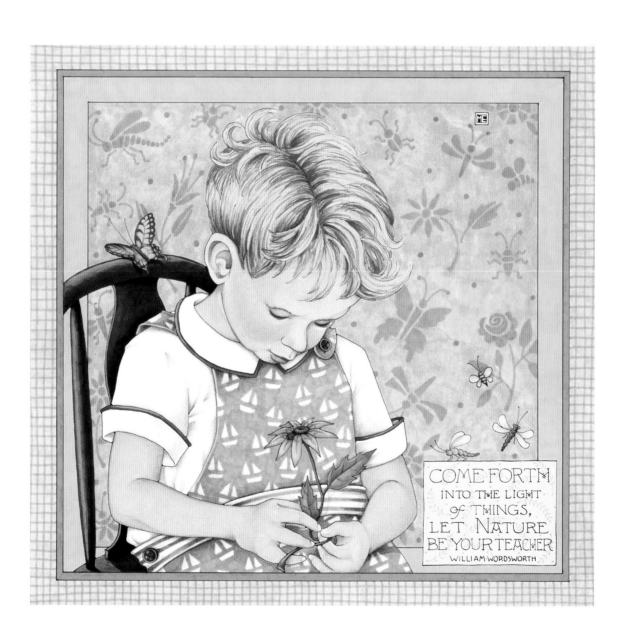

COME FORTH
INTO THE LIGHT
of THINGS,
LET NATURE
BE YOUR TEACHER
WILLIAM WORDSWORTH

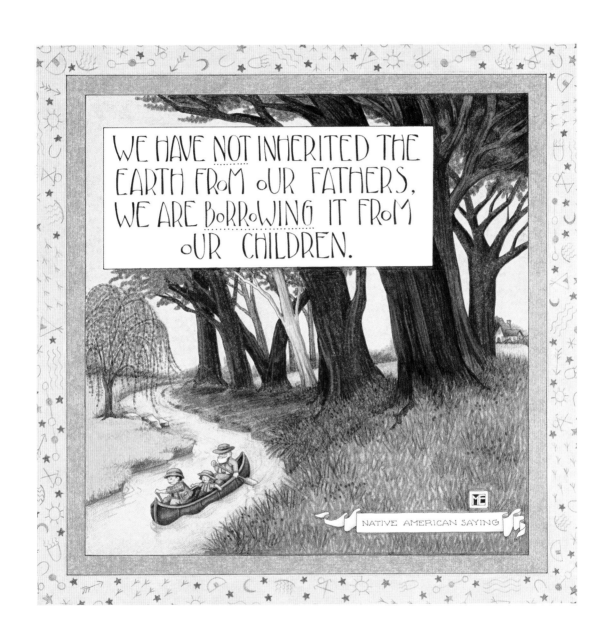

WE HAVE NOT INHERITED THE EARTH FROM OUR FATHERS, WE ARE BORROWING IT FROM OUR CHILDREN.

NATIVE AMERICAN SAYING

INSANITY IS DOING THE SAME THING OVER AND OVER AGAIN, BUT EXPECTING DIFFERENT RESULTS.

ALBERT EINSTEIN

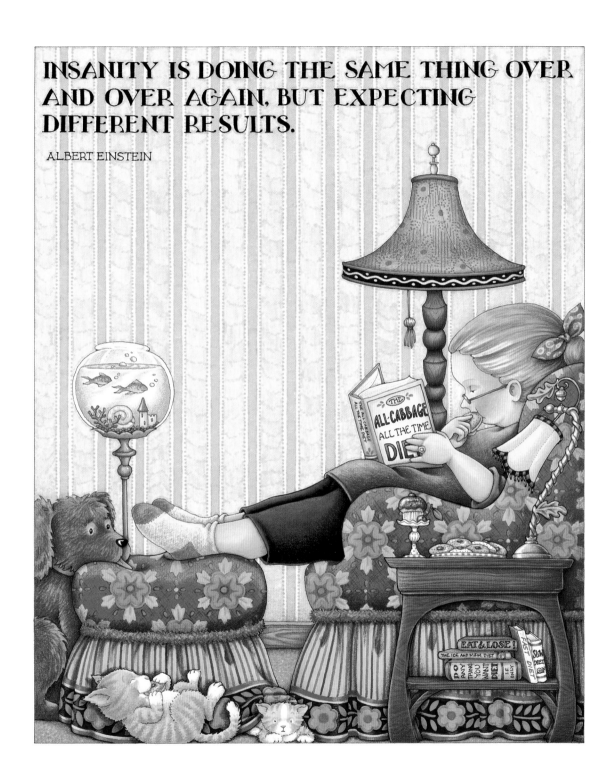

from me to you

I love this quote.
I do believe that there are all kinds of opportunities in life,
but you have to participate.
Nothing is just going to happen to you.
Nothing is going to fall in your lap.

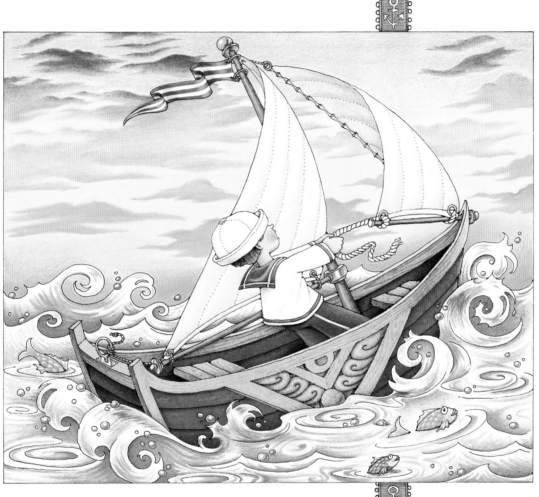

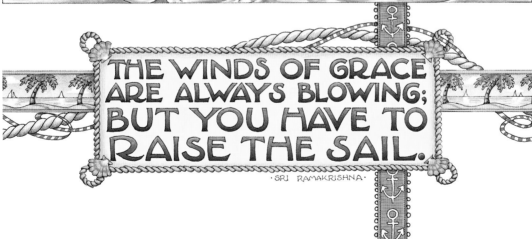

THE WINDS OF GRACE
ARE ALWAYS BLOWING;
BUT YOU HAVE TO
RAISE THE SAIL.

·SRI RAMAKRISHNA·

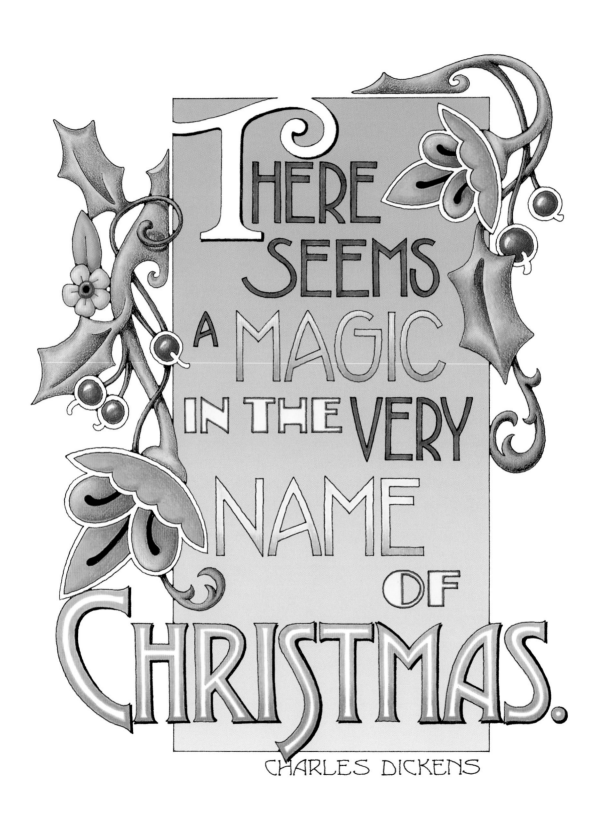

THERE SEEMS A MAGIC IN THE VERY NAME OF CHRISTMAS.

CHARLES DICKENS

holidays

When it comes to Christmas, Mary Engelbreit is of two minds. She loves the classical Victorian vision of the season typified by the words of Dickens and Tennyson, but she also shares a child's unrestrained excitement for Christmas summed up in her own classic line, "Is Christmas Fun or What?"

Over the years, Mary has shown an unmatched ability to capture the many scenes, moods, and traditions of Christmas. A pre-holiday baking session between mother and daughter, a shy child's first time on Santa's lap, the reverent stillness of a snow-blanketed winter evening, the irresistibly amateurish school pageants, and many jolly depictions of the "Man of the Hour" himself—all have received the Engelbreit treatment and thus been embroidered into the fabric of the season.

The spirit of Christmas has inspired writers and poets for centuries, and Mary, in turn, has found plenty of inspiration in their words. The nostalgic feel of Mary's work is perfectly matched by one of her favorite quotes from Charles Dickens: "Remembrance, like a candle, burns brightest at Christmastime."

Like Dickens, who gave future generations a perennial holiday gift with his beloved story *A Christmas Carol*, Mary has made her own indelible mark on the way we celebrate the season. Her enduring message, which lies at the heart of all her Christmas art, was most memorably distilled into one word that serves as both reminder and gentle exhortation. The word? Believe.

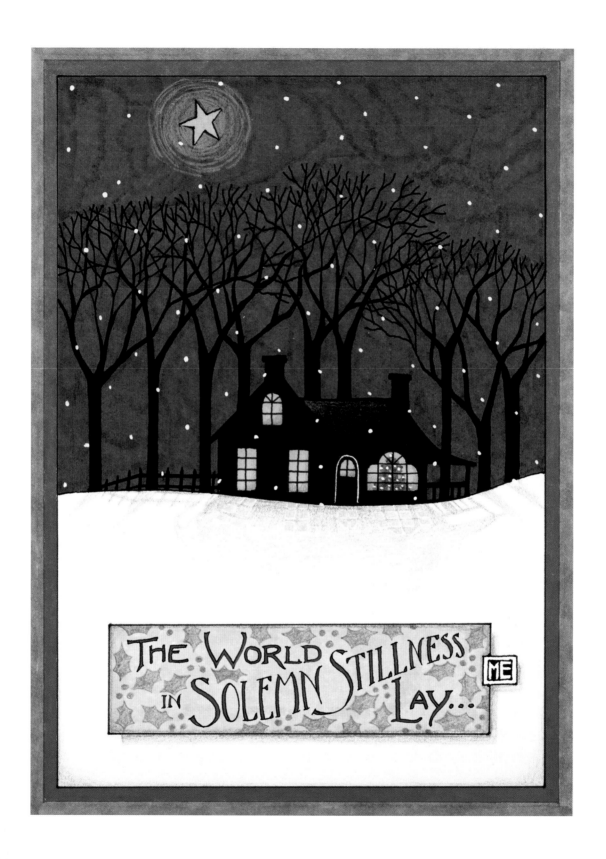

THE WORLD IN SOLEMN STILLNESS LAY... ME

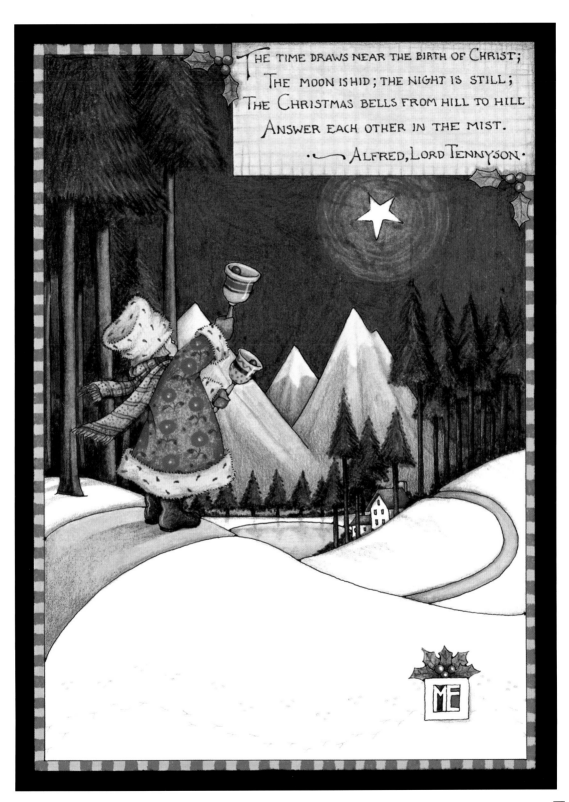

THE TIME DRAWS NEAR THE BIRTH OF CHRIST;
THE MOON IS HID; THE NIGHT IS STILL;
THE CHRISTMAS BELLS FROM HILL TO HILL
ANSWER EACH OTHER IN THE MIST.

· ALFRED, LORD TENNYSON ·

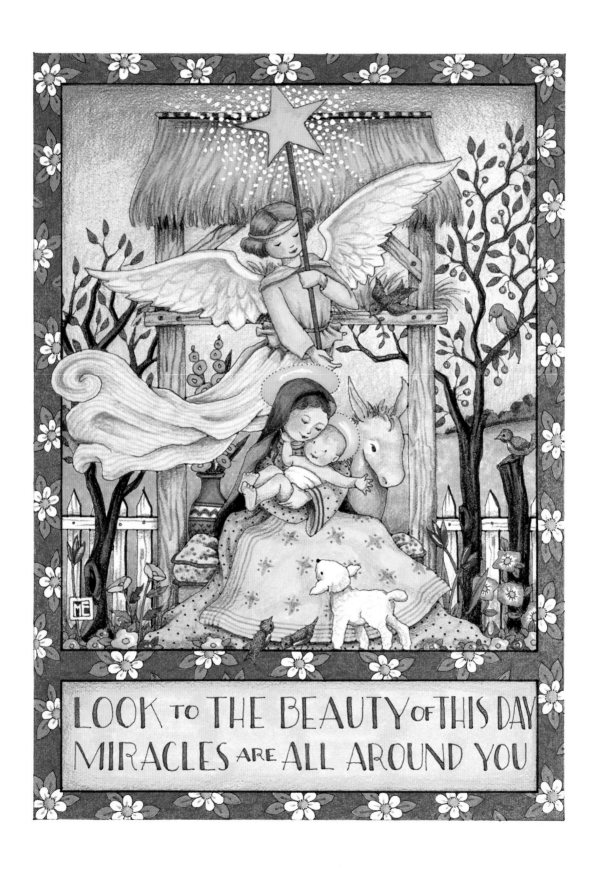

LOOK to THE BEAUTY of THIS DAY
MIRACLES are ALL AROUND YOU

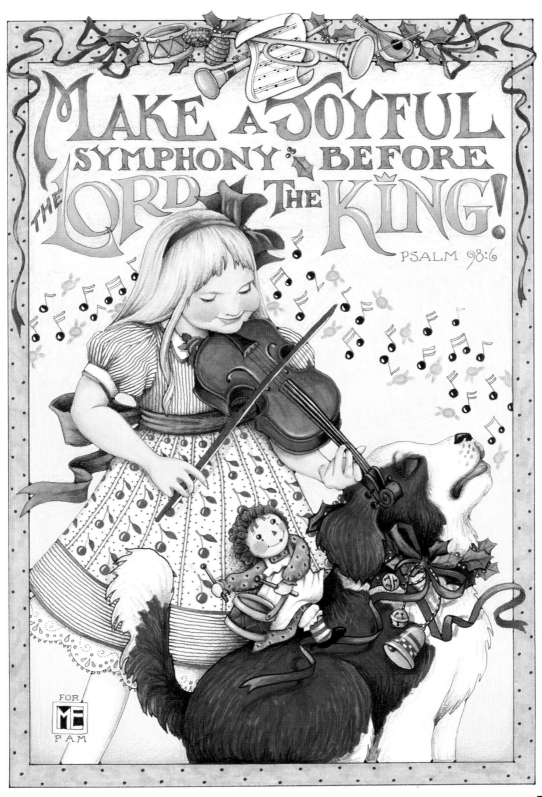

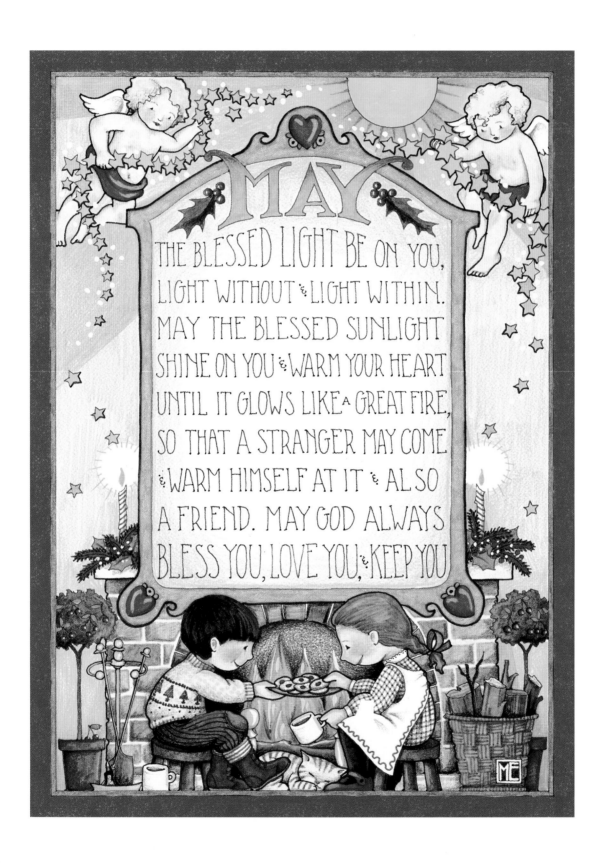

MAY THE BLESSED LIGHT BE ON YOU, LIGHT WITHOUT & LIGHT WITHIN. MAY THE BLESSED SUNLIGHT SHINE ON YOU & WARM YOUR HEART UNTIL IT GLOWS LIKE A GREAT FIRE, SO THAT A STRANGER MAY COME & WARM HIMSELF AT IT & ALSO A FRIEND. MAY GOD ALWAYS BLESS YOU, LOVE YOU, & KEEP YOU

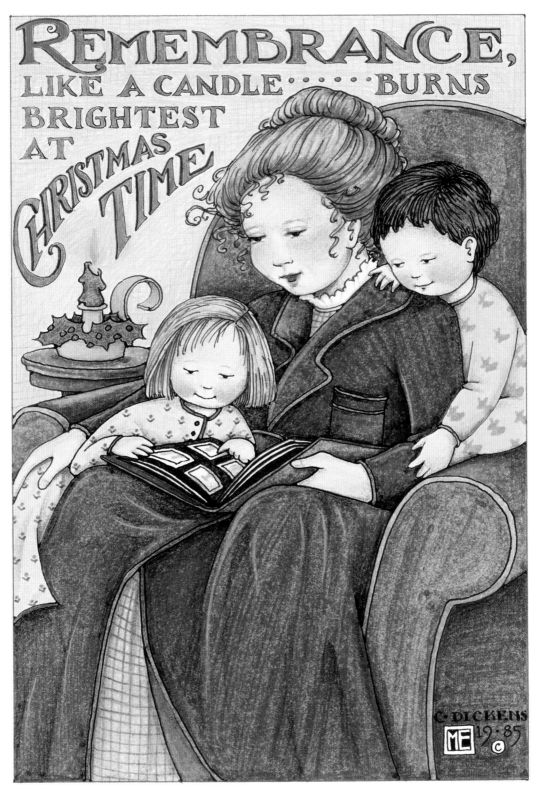

REMEMBRANCE, LIKE A CANDLE ····· BURNS BRIGHTEST AT CHRISTMAS TIME

C. DICKENS

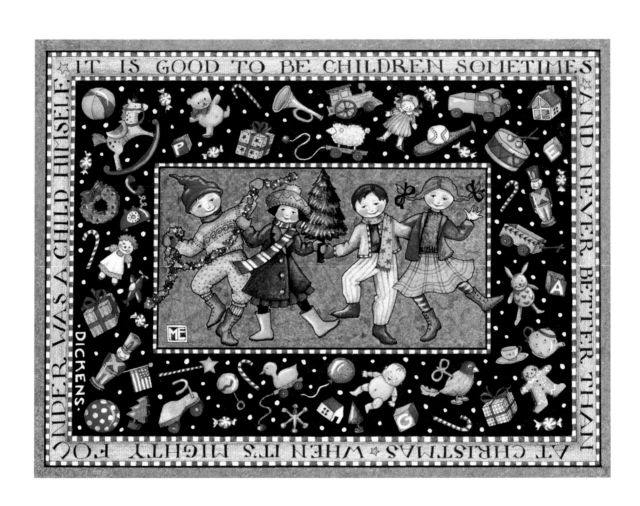

IT IS GOOD TO BE CHILDREN SOMETIMES AND NEVER BETTER THAN AT CHRISTMAS WHEN IT'S MIGHTY FOUNDER WAS A CHILD HIMSELF

·DICKENS·

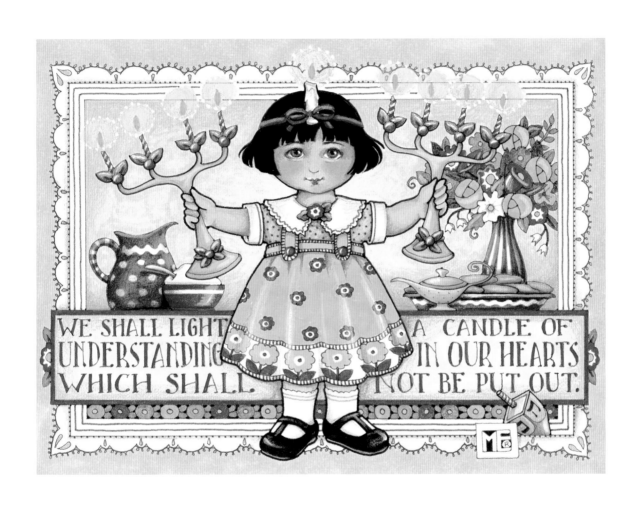

WE SHALL LIGHT A CANDLE OF UNDERSTANDING IN OUR HEARTS WHICH SHALL NOT BE PUT OUT.

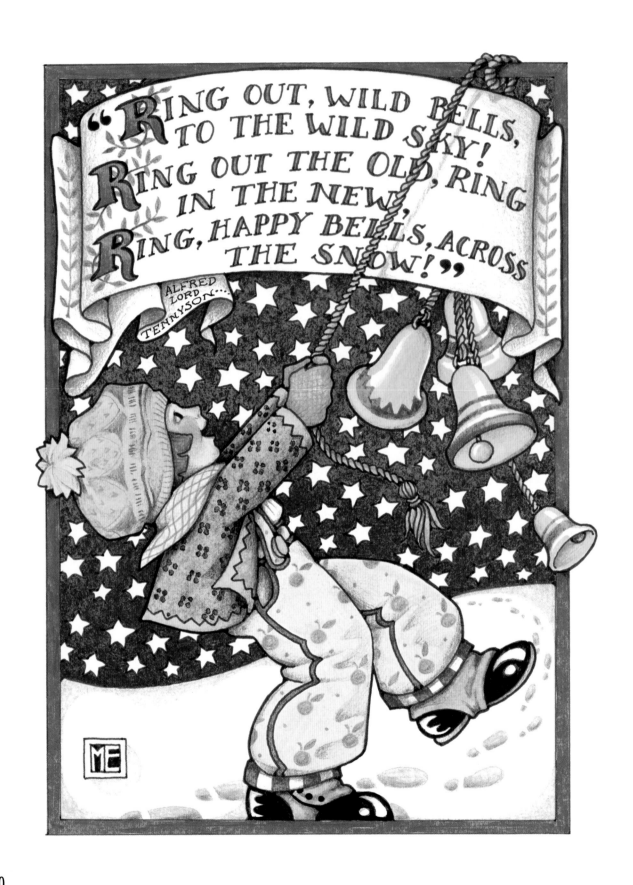

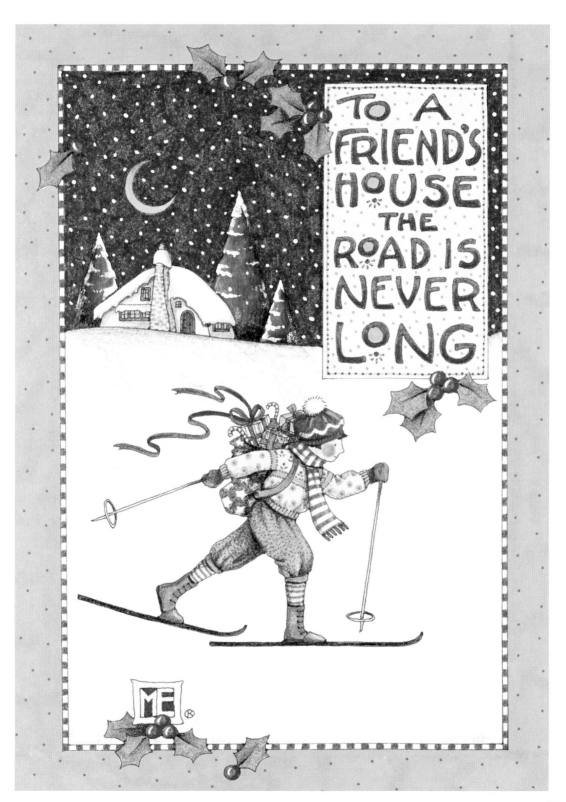

TO A FRIEND'S HOUSE THE ROAD IS NEVER LONG

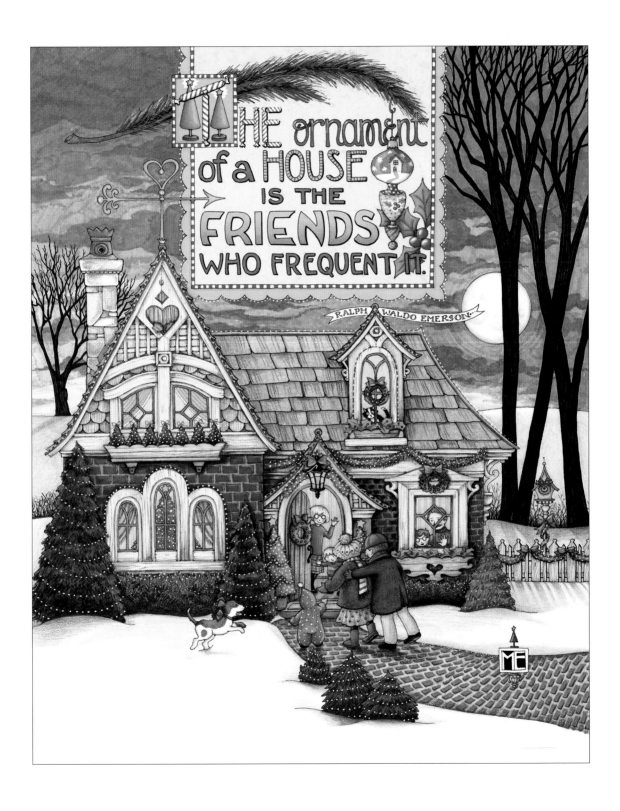

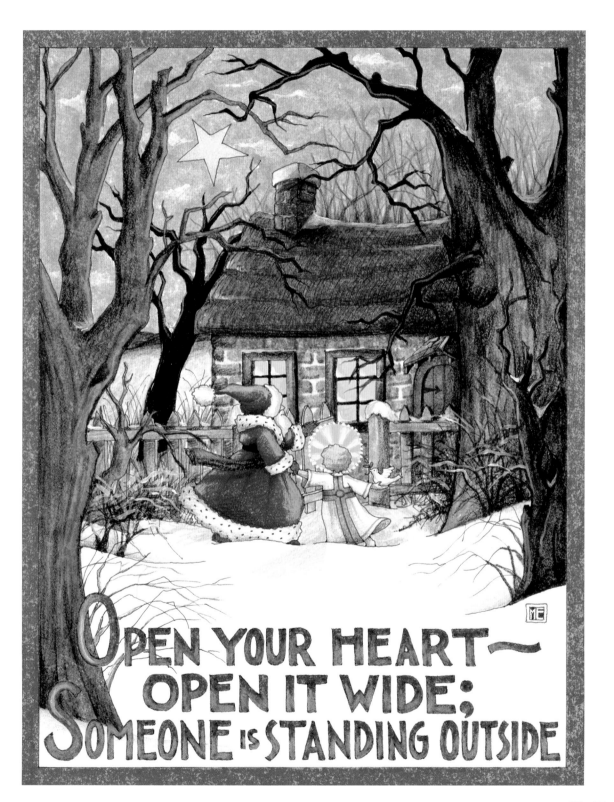

OPEN YOUR HEART~
OPEN IT WIDE;
SOMEONE IS STANDING OUTSIDE

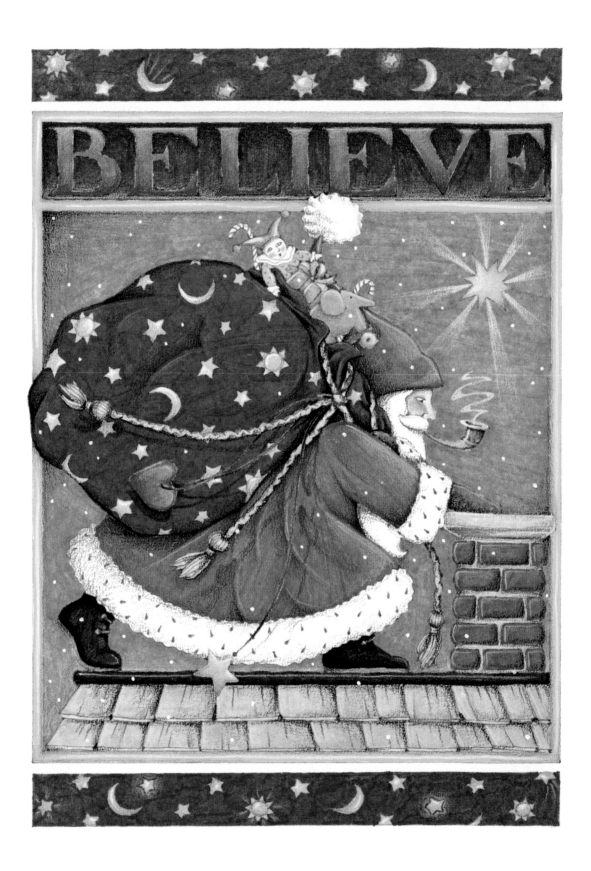

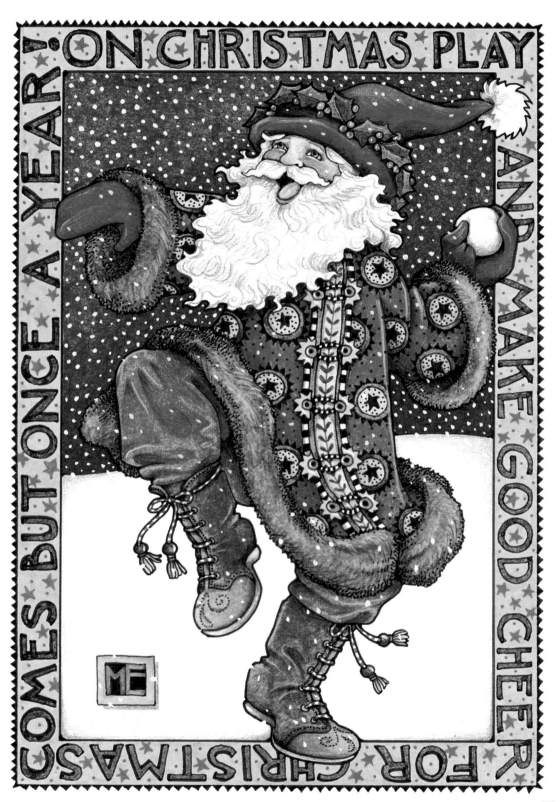

ON CHRISTMAS PLAY AND MAKE GOOD CHEER FOR CHRISTMAS COMES BUT ONCE A YEAR!

135

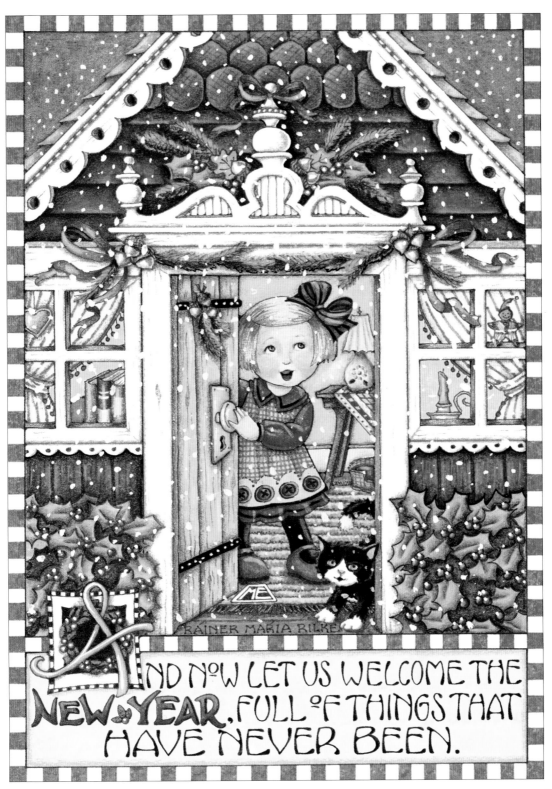

RAINER MARIA RILKE

AND NOW LET US WELCOME THE NEW YEAR, FULL OF THINGS THAT HAVE NEVER BEEN.

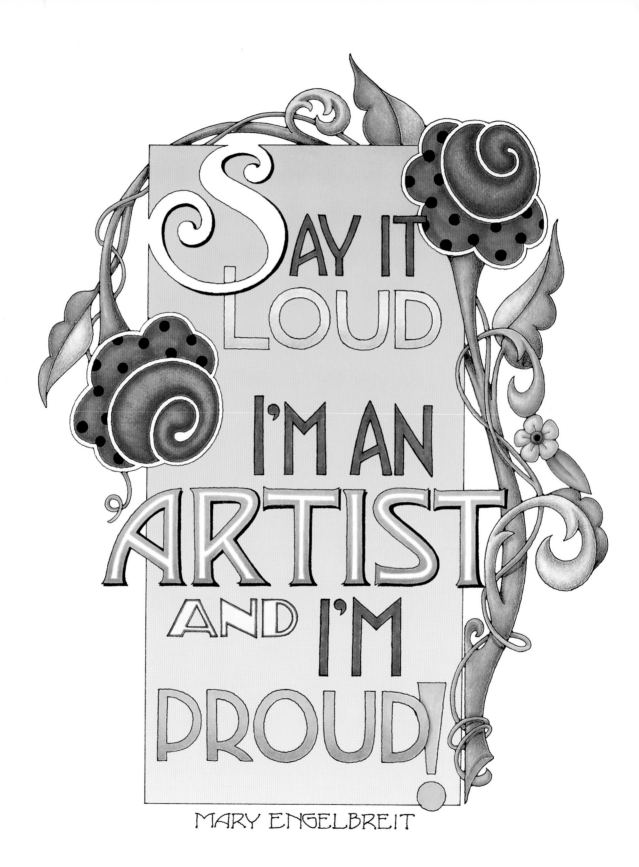

MARY ENGELBREIT

pure mary

to truly know an artist, look closely at her work. Each of the drawings collected in this book gives insights into Mary Engelbreit's personality. Each is to some degree a personal statement. But the drawings and quotations gathered in this particular chapter provide perhaps the clearest picture of all.

Collected here are some of the most definitive and iconic Engelbreit creations of her long career. They include pieces that helped her break out commercially and pieces that have become entire themes in their own right. Mary's series of "royalty" designs began with her first drawing of The Queen of Everything about fifteen years ago. The ensuing years saw the royal family grow with creations like The Princess of Quite-a-Lot, The Queen Mother, The Queen of the Kitchen (with a spatula for a scepter, naturally), and even, more recently, The Prince of Whatever's Left.

The slogans that appear on most of the drawings in this chapter came from Mary herself. As much as she appreciates the work of great writers and loves to share meaningful quotes, sometimes she has her own point to make. And as her friends will tell you, Mary has a particular talent for speaking her mind.

So, welcome now to a refreshingly candid side of Mary Engelbreit, where curt meets cute and her playfulness with words comes shining through. Whether serene (A Little Peace of Quiet) or slightly snippy (Snap Out of It!), all of these images are pure Mary.

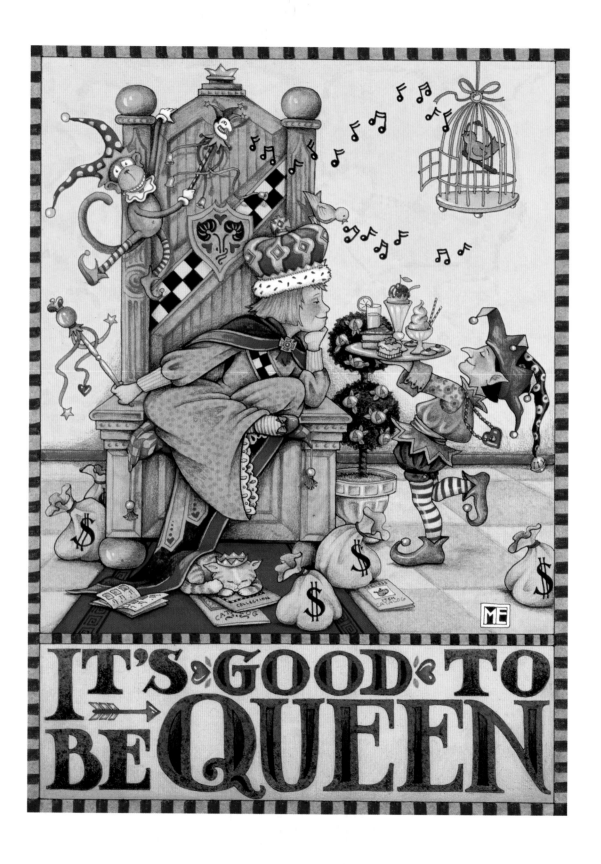

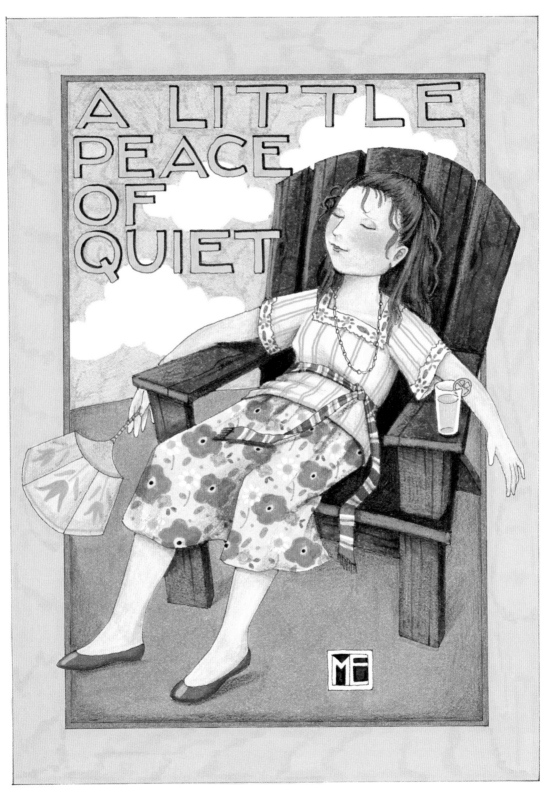

from me to you

I did this because in the early days,
 people (especially people on the East and West Coasts)
were always saying, "Oh, you can't start a card company.
 You can't do it this way. You can't do it that way."
Of course, we *did* do it that way.
The funny thing is this greeting card was a best-seller in New York.
So many people in New York and California
just don't have any idea about the rest of the country.
I've met several people from the coasts who assume that
 because I'm from the Midwest, I live on a farm.
So this was for all of them.

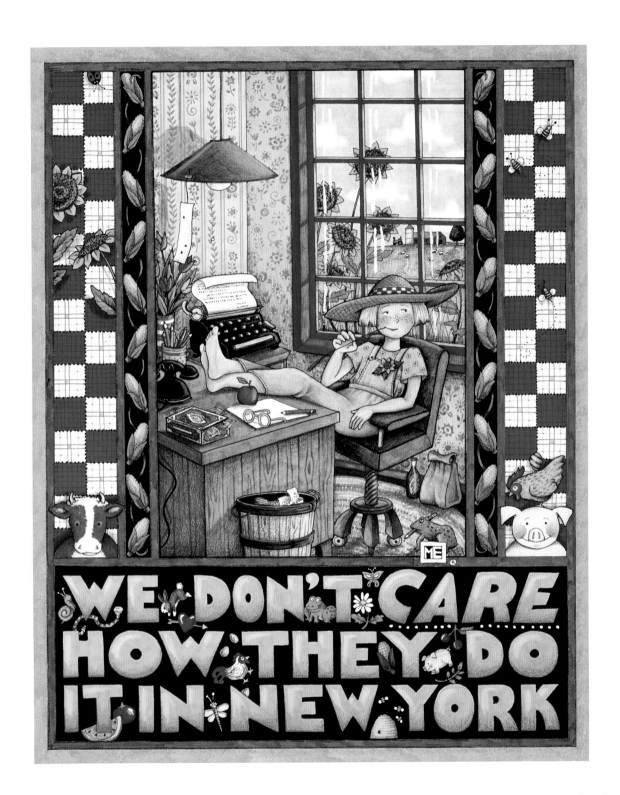

from me to you

I think by now everyone knows the story behind this quote.
The father of an old boyfriend of mine said this accidentally.
I stored the line away,
and when I drew my first "real" greeting cards to sell,
this was one that really got noticed.
The old beau has since told me that I have it wrong,
but now it's my story and I'm sticking with it.

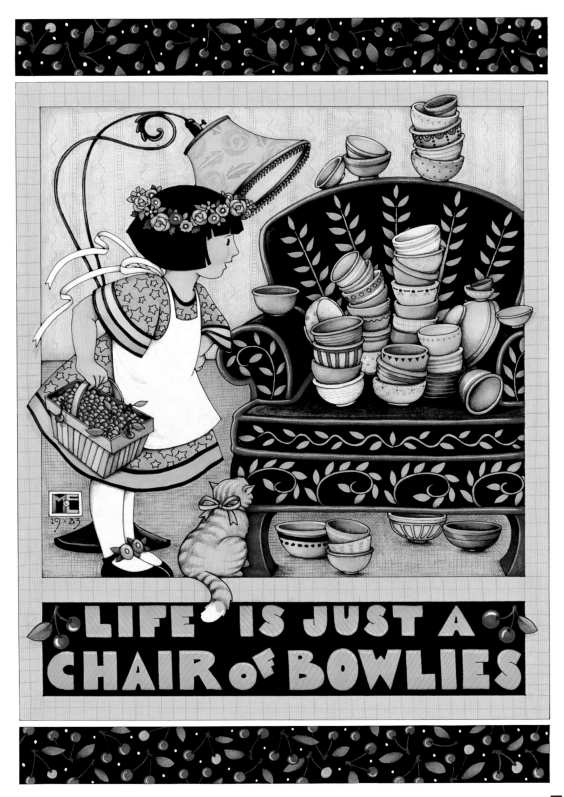

LIFE IS JUST A CHAIR of BOWLIES

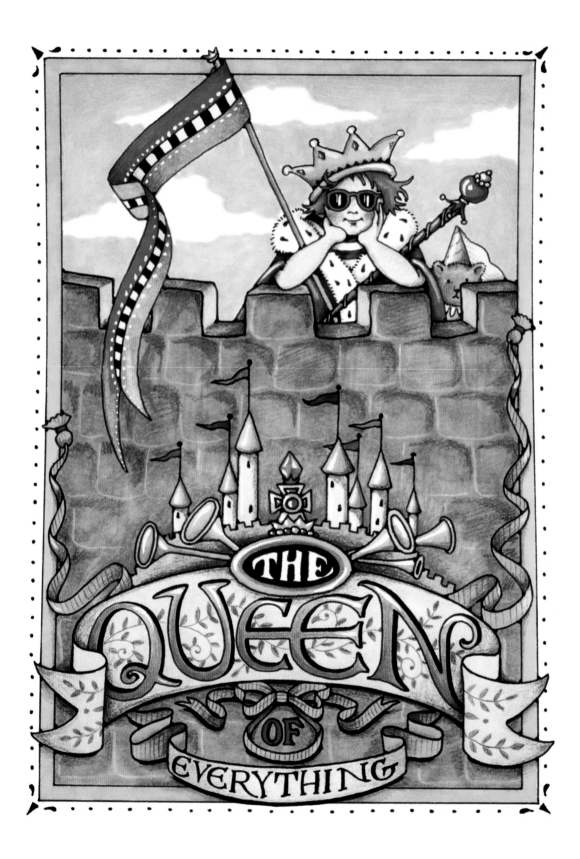

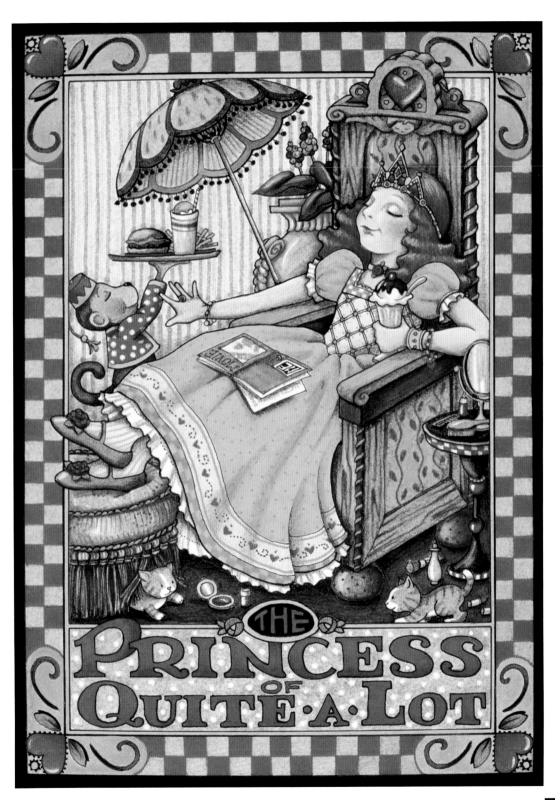

THE
PRINCESS
OF
QUITE·A·LOT

from me to you

I love this quote.
For many years I did the Christmas card for the St. Louis Art Museum.
I would go look through their collections and let them inspire me.
It was very fun. This illustration was inspired by the quote,
but there are references to the museum all through the drawing.
I tried for a long time to persuade the company
that does my greeting cards to use this,
but they worried that it was too complicated for the average customer.

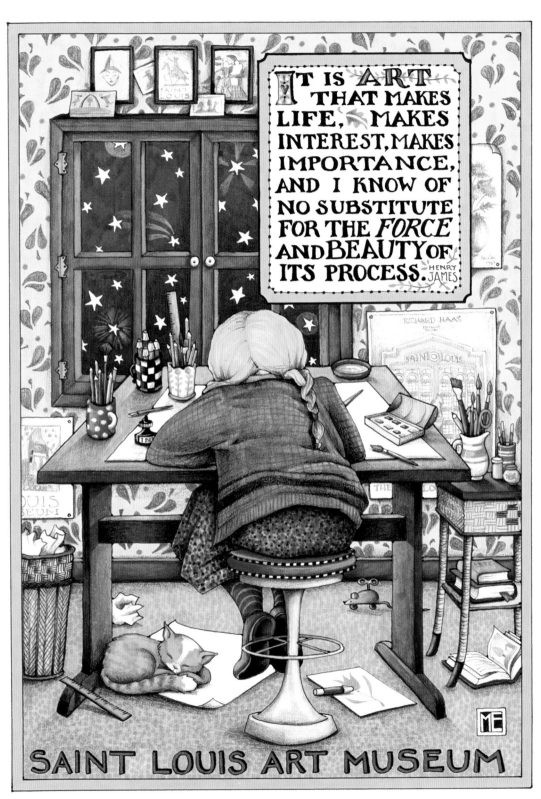

IT IS ART THAT MAKES LIFE, MAKES INTEREST, MAKES IMPORTANCE, AND I KNOW OF NO SUBSTITUTE FOR THE *FORCE* AND BEAUTY OF ITS PROCESS. — HENRY JAMES

SAINT LOUIS ART MUSEUM

from me to you

My uncle gave me the whole idea for this card.
He called me up and said, "I have this cool idea for a card,"
and he told me the line and suggested that I draw a kid with a dog.
I loved the idea, and I drew my son with our dog, Rosie.
I put my uncle's name on it and he was thrilled.

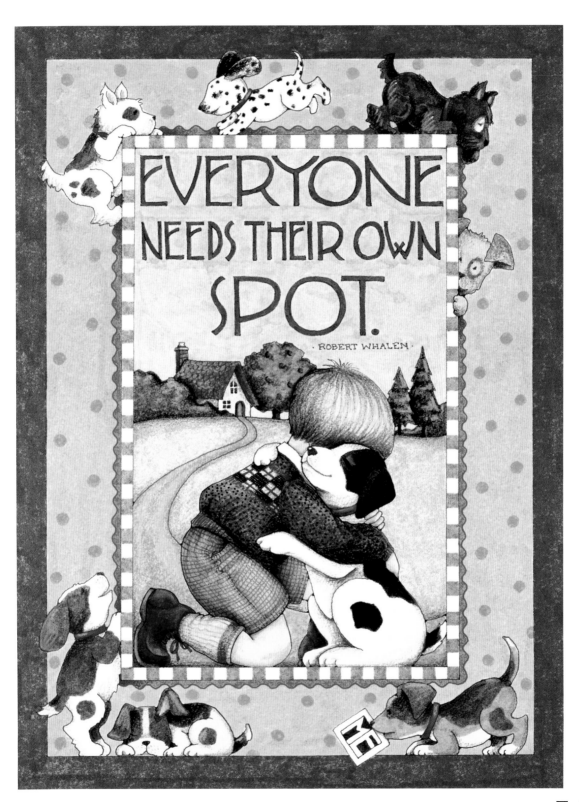

EVERYONE NEEDS THEIR OWN SPOT.

· ROBERT WHALEN ·

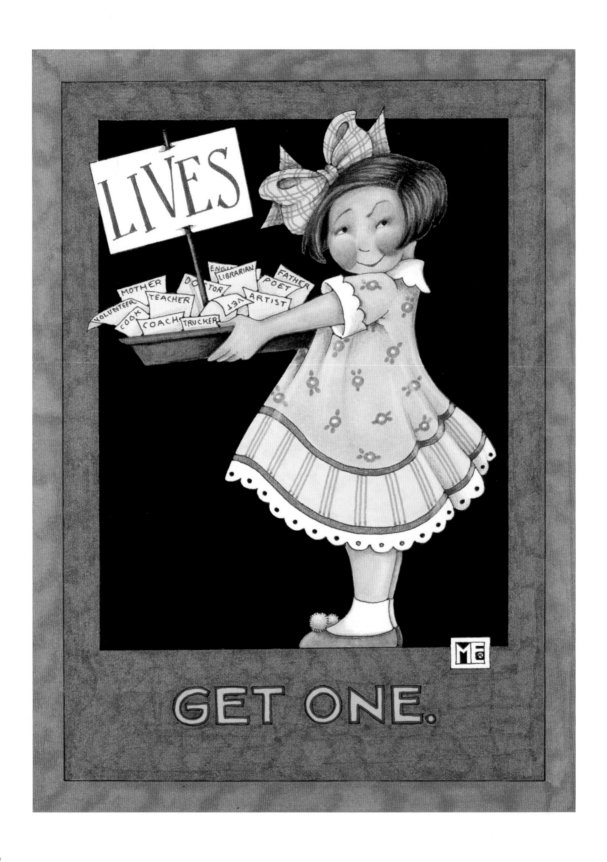

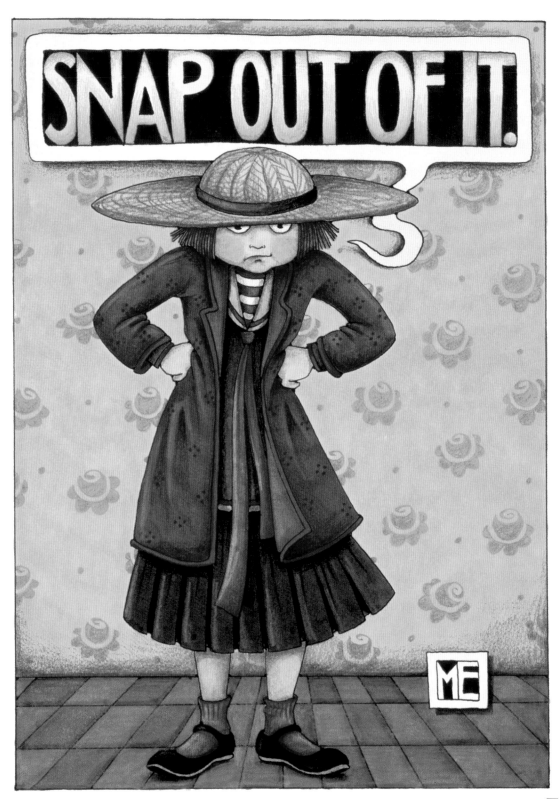

from me to you

I love this quote from T. S. Eliot.
 I did the illustration when the kids were little—
my older son was just about kindergarten age.
 Every parent knows this feeling.
You hope you did everything right
 and hope that you're doing the right thing,
sending them out into the world.

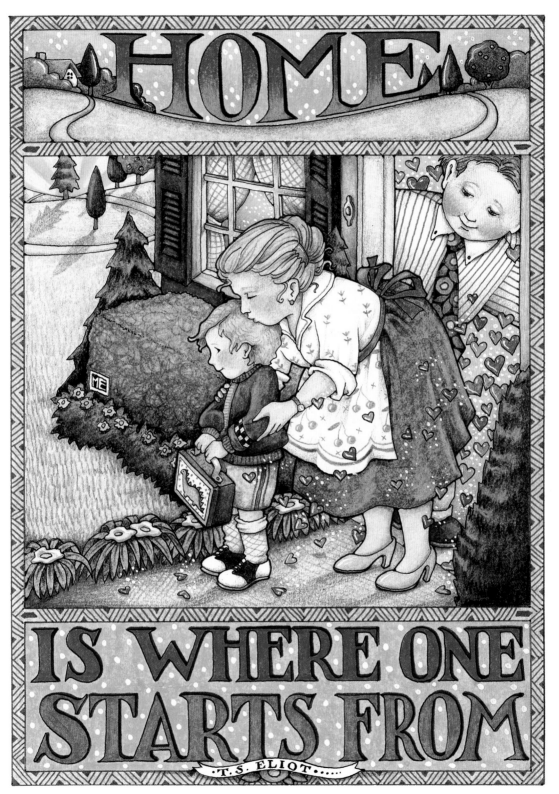

HOME

IS WHERE ONE STARTS FROM

·T.S. ELIOT·····

155

from me to you

That is actually my Aunt Audy, my mom's sister,

watering the window box.

This saying was on a little sampler that hung in her kitchen,

and I always thought it was such a good quote.

Aunt Audy loved quotes just like my mother (and me).

I remember the sampler from when I was a little girl.

Even then, I knew a good quote when I saw one.

I guess I was destined to go into the greeting card business.

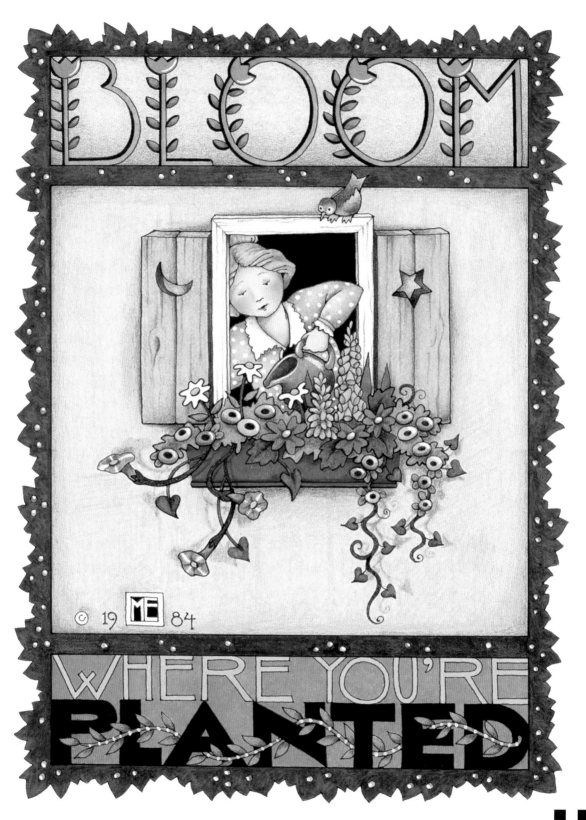

BLOOM WHERE YOU'RE PLANTED

© 19 84

from me to you

What can I say?
 I come from a fine dysfunctional family,
 as does everyone else I know.
Actually, I first saw this quote on a bumper sticker
 and liked it so much that I just had to turn it into a card.
I guess everyone can relate because it's become a very popular card.

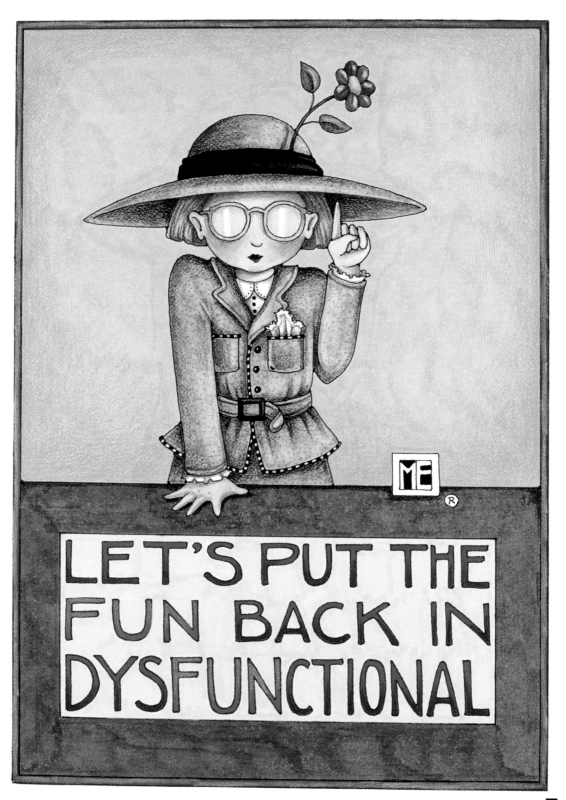